A Life on Paper

A Life on Paper

The Drawings and Lithographs
of
John Thomas Biggers

OLIVE JENSEN THEISEN

University of North Texas Press
Denton, Texas

10 9 8 7 6 5 4 3 2 1

Permissions:
University of North Texas Press
P.O. Box 311336
Denton, TX 76203-1336

The paper used in this book meets the minimum requirements of the American National Standard for Permanence of Paper for Printed Library Materials, z39.48.1984. Binding materials have been chosen for durability.

Library of Congress Cataloging-in-Publication Data

Theisen, Olive Jensen.
 A life on paper : the drawings and lithographs of John Thomas Biggers / Olive Jensen Theisen.
 p. cm.
 Includes bibliographical references and index.
 ISBN-13: 978-1-57441-220-8 (cloth : alk. paper)
 ISBN-10: 1-57441-220-5 (cloth : alk. paper)
 1. Biggers, John Thomas, 1924- 2. African-American artists--Biography. I. Biggers, John Thomas, 1924-2001. II. Title.
 N6537.B52T55 2006
 760.092--dc22
 [B]
 2006012297

Cover Image *Cradle* is reproduced courtesy of The Museum of Fine Arts, Houston; 25th Annual Houston Artists Exhibition, museum purchase prize, 1950.

The author would like to thank the Minnie Stevens Piper Foundation and the Houston Endowment Inc. for their generous support, which made the publication of this book possible.

Dedication

To Hazel Biggers

whose strength, encouragement, and devotion made possible

John Biggers's rich life on paper.

Contents

Acknowledgments

John Biggers spent many hours tossing about ideas on drawing, art, and life while Hazel Biggers listened, cooked, and interjected her insightful comments. I sat at the dining table with tape recorder, pen, and yellow pad, with questions in mind. I am so thankful for this friendship that grew from a serendipitous event, led into a book on his murals and now into this book. Because of Dr. Biggers's illness and death in 2001, I had stopped working on the project and put away my tapes, notes, and slides. But thanks to Dr. D. Jack Davis's encouragement and Hazel Biggers's readiness, I submitted a book draft to the University of North Texas Press, which eventually was followed by a publication contract.

Many of the photographs in this book were selected from John Biggers's personal collection and I gratefully acknowledge the use of those images. The Museum of Fine Arts, Houston, the Dallas Museum of Art, the Harry Ransom Humanities Research Center in Austin, the Michael Rosenfeld Gallery in New York, and the University of North Texas School of Visual Arts have graciously provided necessary photographs. The Texas Commission on the Arts in 1992 made it possible to photograph drawings from personal collections. At that time, Dr. and Mrs. Joseph Pierce, Jr., Dr. and Mrs. Richard Mosby, and Dr. and Mrs. Robert

Galloway kindly opened their homes and permitted photography. Photographers for the book were John Biggers, Earlie Hudnall, Sherry Fisher Staples, Ronnie Barker, Nancy Walkup, Olive Theisen, and Jessica Cook.

The generous financial support of the Houston Endowment and the Minnie Stevens Piper Foundation is most gratefully acknowledged. Without them, this book would not have been possible. And finally, my deep thanks go to Karen DeVinney, editor of the UNT Press, and Dr. B. Stephen Carpenter, III, for their editing suggestions. It has been a joy and a privilege.

An Introduction

EXAMINING THE QUILT:
THE LIFE OF AN AFRICAN AMERICAN PIONEER IN THE VISUAL ARTS

CHAPTER ONE

*I*t is 1952. The place is the Blue Triangle YWCA in Houston's Third Ward. An artist is at work, painting a mural picturing downtrodden slaves with the heroic figures of two dynamic black women, Sojourner Truth and Harriet Tubman (fig. 1). These women are life size, with powerful hands and feet, not delicate beauty queens. An irate female voice interrupts the quiet concentration of the artist. "Come down, young man. Get down from the wall and stop this flagrant disrespect immediately. The image of the slave and especially Harriet Tubman disgrace Negro womanhood." It takes a week or so of explanation and discussion before YWCA officials are able to convince the vociferous critics that the artist's depiction of the black women has value. Then John Biggers is permitted to resume his painting.[1]

Today the situation is different: not necessarily better, but different. Although racism still exists and remains a critical issue for our nation, popular culture for young African Americans has changed considerably. There are now larger-than-life figures of people of color in every walk of life: the arts, the sciences, politics, religion, medicine, business, sports, music, and entertainment. Urban hip-hop

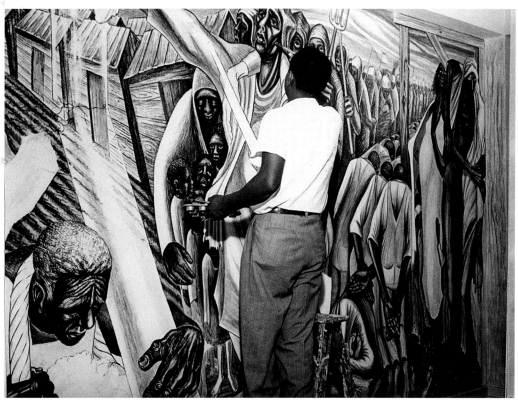

figure 1
John Biggers painting at
Blue Triangle YWCA
1952

culture inspires the music, fashions, and behaviors often emulated by the younger generations.

When John Biggers was a young man, the segregation of the races was an implicit part of the social contract, a bitter remnant of slavery's evil. Though it was understood, it was seldom addressed or confronted. President Harry Truman had not yet desegregated the United States Armed Forces. Persons with dark skin were required to sit or stand at the rear of a bus or streetcar. Lynching was one punishment for violators of these unwritten laws, and every family had some personal acquaintance with that terrible practice. There were no Negro ball players on major league teams, no great black football or basketball players.

In some parts of the country segregation was explicitly mandated. Throughout the South, public restaurants, drinking fountains, and restrooms were maintained separately for "white" and "colored" people. Voting in elections was only a distant dream for many. Poll taxes and other harassing techniques were used to prevent the Negro from exercising the right to vote.

The practice of segregation extended to the creative arts communities as well. Negroes were permitted entrance to art museums on only one day of the week, usually Thursday. Black people were allowed to sit only in the back of the movie theatres or in the balcony. Few serious dramatic roles were available for black actors and actresses. Great Negro musicians were often submitted to the indignities of segregation as they toured the country. Despite the fact that there were talented and skilled black artists, recognition and therefore financial success were commonly denied the visual artist of color. It was as though the black people of the United States were, as Ralph Ellison said, nearly invisible.

So when young John Biggers entered college at Hampton Institute, Hampton, Virginia, in 1941, he registered with the intention of learning a practical trade, such as plumbing. But a visionary teacher opened the doors of possibility to this gifted young man. John Biggers left that institution in 1946 as a deeply committed artist, knowing that his calling would be to tell the honest story of the Negro in America through his art, to make the invisible known and respected. One of his greatest themes would be that of revealing the dignity of ordinary people.

Some seventy years later, the name John Biggers still evokes respect and admiration from those whose lives were touched by this man. The artist influenced countless numbers of art students in his thirty-three years spent building a career and an art department at Texas Southern University, in Houston, Texas. He forged a career as an illustrator, draftsman, muralist, painter, sculptor, and lithographer during an era in which African American artists had almost no possibility of recognition. Through his drawings he first found the voice that began to resonate with the public. Some of his works have aroused hostility, anger, and embarrassment while others have brought praise and high honors. Although he died in 2001, his art endures and continues to elicit both pride and controversy.

Looking back at his long career, John Biggers often remarked: "It is the drawings that I love to do the most."[2] And it is those drawings, and the lithographs

from the drawings, that suggested the focus for this book. While this artist gained recognition as painter and muralist, it is his drawings that he cherished. He kept many of them in his possession, filling the house and studio to overflowing, living with them year after year, as beloved children. For John Biggers, his work always began with a drawing pencil or a stick of conté crayon.

As a child, John Biggers grew up watching his big brothers draw, and drew with them. Following the death of his father when he was a young adolescent, he was enrolled at a nearby boarding high school. He often used his precious spare time to draw from engravings in magazines. Puzzled, his friends would ask him why was he doing that. John would answer that he did not know; he just wanted to draw. At Hampton Institute, his passion for drawing brought John to join an evening drawing class that introduced him to the charismatic man who was to be his life-long mentor, Viktor Lowenfeld. While in the Navy Seabees during World War II, Biggers drew to make some sense of his terrible experiences. His power-fully expressive drawings received important awards in the 1950s, bringing John Biggers to the attention of the artistic community.

Biggers's early drawings did not appear to be greatly different from those of other beginning draftsmen, with common errors in perspective and proportion. However, there was an emotional intensity and attention to detail that was far less ordinary. And as Biggers continued to draw, his characteristic style developed. He would apply small hatching and cross-hatching strokes to the paper with pencil or crayon. With this technique he was able to create volume while controlling the overall light and dark values in a drawing. In many of his early murals, he applied his paint with small brushes, stroke by tiny stroke. When asked about the origins of this exceptional technique, Biggers thoughtfully replied: "Many a day as a kid, I watched the chickens scratch in the red earth. They formed a pattern when they scratched. But they're not just scratching, they will go in a rhythm of right, left, right, left. And I saw form in those scratches." Pausing to reflect on his memories,

he added, "Later on, when I'd be drawing, I'd create those patterns and rhythms in crosshatching … with just my black conté crayon, I could draw almost everything I want."[3]

His dark eyes smiled triumphantly at his last comment. But then, excitedly, he leaned forward and rolled on: "One of the most wonderful thrills for me in drawing is to work on a white sheet of paper, crosshatch it very lightly, so that when you let a thing become white, it truly sparkles. That sparkle comes because there are no other whites on the paper to compete with it. It makes the light pop up." He paused for a moment again and added: "You have to use an eraser sometimes. You have to sort of know where you want that white light to be. You leave it there and gradually work toward it. You scratch towards the light, but very lightly … approaching and retreating, approaching and retreating. It's an organic way of drawing."[4]

There are as many reasons for creating art as there are artists. Some create for religious or social purposes, others to express personal feelings. Some make art to invent a new aesthetic form, while others evoke art for nostalgic or commercial purposes. Most move from one theme to another as their interests change. But John Biggers's passionate belief in the power of art kept him committed to his goal while he matured in his skills and techniques to develop a language of metaphoric images. At that time, there were other talented undervalued artists of color in his generation, but his singleness of purpose was without parallel.

With that never-ending urge to draw, John Biggers left hundreds of drawings, more than could be included in one book. Although many were stored, some were sold, others traded, and some he gave to cherished friends. At the end, John Biggers left unfinished sketches on his drawing board. With Dr. Biggers, this author chose a selective but comprehensive picture of the drawings and lithographs of John Biggers. But as we read through this book, John Biggers not only tells his

story as one individual American, but also reflects the struggle of a nation moving from its segregated past into the reality of the present with hope for the future.

John Biggers's mother once made him a quilt that he kept by his side as he worked. That quilt became an important symbol for him and, later, an important structural device in his work. Thinking about the way in which a quilt is created seemed to suggest a metaphor for the development of *A Life on Paper: The Drawings and Lithographs of John Thomas Biggers*. Chapter Two begins by looking at the first pieces of that quilt.

Early Years and Education, 1924–1949

FIRST PIECES OF THE QUILT

CHAPTER TWO

John Thomas Biggers was a true child of the South. Born April 13, 1924, and raised in Gastonia, North Carolina, his ideas, values, memories, and talent were formed by his home and the circumstances of his birth. Growing up as a black child in a racially segregated time in the southern half of the United States deeply influenced his view of the world. Biggers's drawings are filled with references to aspects of life that are far removed from our current preoccupation with technology and political and global matters. Yet these drawings speak so strongly of the human condition that they cannot be forgotten.

The early drawings of John Biggers centered on family and community in the rural South in the Great Depression, World War II, and the post-war era of the 1950s. He was a gifted African American artist who came to adulthood in the decades preceding the historic civil rights movement. He is best understood as one of the African American pioneers in the visual arts who developed his career despite the conditions that made the fight for civil rights inevitable.

What was it about growing up as the youngest son of Paul and Cora Biggers in Gastonia, North Carolina, that made John Biggers's life so rich with memories

and images that he would spend the rest of his life finding ways to tell that story? John Biggers was the cherished baby, the last of four brothers and three sisters. There were fifteen years' difference in age between John and the oldest sibling, Sylvester, making the two oldest brothers teenagers when he was a toddler. His older sister Lillian died at age ten from diabetes. As with many large families, the older children—Sylvester, Jim, and especially Ferrie and Sarah—had to take care of the younger ones. That could have been a real burden, but older sister Ferrie recalled with a laugh, "Oh, we didn't mind. He was such a darling baby—we all just loved him!"[1] Everyone had chores to do to keep the household running. Paul and Cora Biggers ruled their brood with a firm but loving hand. In the video *John Biggers's Journeys*, Biggers describes his parents as strict and loving, saying that his mama ruled the house but his father was the power behind the throne. "Daddy and Mama both demanded that you work your can off. We'd often hear those words, 'Don't say you *cain't* do it. There's no such word as *cain't*. You can do it.'"[2]

Biggers's parents met while in school at Lincoln Academy, Kings Mountain, North Carolina. This institution was founded following the Emancipation Proclamation (as were other similar schools throughout the South) to educate the children of freed slaves. Both Cora and Paul Biggers strongly believed in the value of education and reading the Bible as a family. Together they built a strong and loving home in the small closely knit black community, apart from the urban mill town that was Gastonia, North Carolina.

Paul Biggers was a remarkable man. He was one of a pair of twins born to his half-black, half-Cherokee mother, who had been a slave. Her owner, a white farmer, was his father although their black stepfather raised Paul and Saul.[3] Paul lost his leg in a farm accident as a six-year-old boy, but he learned to adapt with one leg and a crutch. As a grown man, he became principal and teacher of a one-room school. Biggers said in an aside to the audience at his mural rededication ceremony: "Now I know about one-room schools. I went to one. There weren't but twelve students

in that school. I went to school with my dad, came home with him. It was so small that he could reach out and swat me."[4]

Paul Biggers had many skills besides teaching school and preaching. He farmed, cobbled shoes, and was a carpenter. Biggers described his father with tender pride: "Paul Biggers was my daddy. His twin brother Sandy (my uncle Saul) lived across the street from us. They each built their family's home. My daddy had only one leg but he used it so well we didn't think he was handicapped. He had a crutch. It was just part of his character."[5]

Paul Biggers taught his children to read before they went to school. They all read together in the evening from the big family Bible as they sat around the fire-place. Biggers's eyes twinkled as he spoke of his parents: "He was a strong man, but Mama ruled the house. 'Be obedient, work as hard as you can, do a good job' were words we heard often in our home. She was a sweet woman. I have nothing but fond memories of both my parents."[6] As if to invoke his parents' presence, his father's cobblers' anvil and his mother's handmade quilt were nestled carefully in his crowded studio, beside his easel and drafting table. Later those loved objects became important symbols in his iconography.

According to an unpublished family document, the Roberts Family History, John's mother, Cora Biggers, was the great-great-granddaughter of an African woman from Guinea who had worked for seven years to pay for her passage to America, yet had been claimed as a slave in Virginia and again in North Carolina. Her great-granddaughter, Lizzy Whitworth, lived on a farm near her daughter Cora and son-in-law Paul in Gastonia. Because he was so much younger than the others, John spent long days in the company of his mother and grandmother. Lizzy Whitworth was a tall and dignified woman whom John sought to honor in several of his mural drawings.[7]

Since John was the youngest, he was with his Mama all day as she went about her chores, and he learned to do the things she did. The house was most certainly

her domain. Preparing the clothes for washing, scrubbing clothes, and hanging them on the line, were all a part of her day along with sweeping, mopping, and baking. John learned it all and he often watched her and his Grandma Lizzy sewing and quilting.[8]

Earning enough money to feed and clothe a large family was a daily challenge. Cora Biggers did what many other women had to do: she took in washing from white families. Without a washing machine, washing clothes was a long, physically exhausting process. In the video *Stories of Illumination and Growth*, Biggers vividly describes his earliest job, which was to start the wood fires under large iron wash pots so that there would be enough clean hot water to soak, scrub, and rinse the clothes. There was always a rub-board nearby that received daily use. By getting those fires started each morning, young John had a very important job to do each day before he set off to school.

With a large family in a small house, evening entertainment usually involved the whole family in one way or another. "At night we'd lie in bed and listen to our neighbors down the hill, singing, playing the piano, and slow drag dancing. The walls of our house were thin so you could hear those sounds all night long. We loved that music but mama would call to us, 'You boys go to sleep.' Then she'd say to my dad, 'Paul, you make those boys be quiet now.'"[9]

Drawing was another evening activity in the Biggers household, especially for the boys. In an era before television, no money for movies, "hanging out" forbidden, teenage boys had to create their own fun. While the girls might be learning to sew and quilt with their mother and grandmother, Sylvester and Jim would take up the pencil and draw.

John said that his brothers Sylvester and Jim were always drawing. "I would want to do what they were doing. I remember standing on a chair so that I could see. I had no patience for my drawings. I just didn't ever make any little child's drawings. I wanted to draw like my big brothers so I started out by copying their drawings."[10]

But those boys were in their teens and John was just a little boy. The neighbors would ask Jim to make pictures for them and Sylvester would do watercolor drawings that were copies from the Bible, or from calendars.

When John was twelve, Paul Biggers died as a result of diabetic complications, so Cora Biggers had to go to work outside the home. The older children by then were on their own. Cora was offered a live-in job at an orphanage in Oxford, North Carolina. John and Joe were sent to Lincoln Academy, the boarding high school nearby where both Paul and Cora had been educated. It proved to be a good solution to the tragic loss of Paul Biggers, the beloved husband and father.

John entered Lincoln Academy in the seventh grade after his father died. The students had an organized and disciplined life. Every boy and girl had to rise at the six o'clock bell, get up, have their showers, and get to the dining hall by 6:30 or 7:00. They had to be in class by eight o'clock. They had about forty minutes for lunch, back in class at 1:00 and at 3:00 they were out. John described a strict attendance policy: "If you weren't in class, well then, where were you? Unless you got ill, or were in the bathroom, there weren't many places where you could be."[11]

Everybody had some kind of a job. Grass had to be cut, leaves raked, the farm to work; there was always some work to do. Eggs had to be gathered, cows needed to be milked, and vegetables had to be picked. John was a football player, too. "Those of us who played athletics had to be ready to practice at 4:30 p.m. Then you had to take your shower, dress, and be in the dining room by 6:00. You had an hour after supper to socialize, go to the canteen, buy your girlfriend a cold drink."[12] To help pay for his schooling, John was assigned a job in the boiler room, watching the furnace and stoking it when necessary. "I always had to hit the boiler room to get the steam up—did that throughout the day. We had to go between classes to check the furnace, make sure the steam was up."[13] That boiler room turned out to be the quiet space John needed to nurture his creative drawing skills. In the quiet, he began to draw.

My first drawings were in the boiler room at Lincoln Academy,

before I knew anything about art at all. I used to copy those beauti-

ful black and white engravings in the New York Times Book Review

that were kept there. I just had an urge to copy them. I didn't know

anything about drawing. Man, there was just something about it, and

my partner was saying, "Why do you want to do that?" I told him, "I

don't know, I just want to." You know? I'd be doing that after we got the

fires up, the steam up, and we'd be just sitting there dozing, and then I

would start drawing.[14]

The head of Lincoln Academy was Rev. Henry Curtis McDonald. He had

been a missionary to Africa, making him one of the few black men in the United

States at that time who had been to Africa. Rev. McDonald planted some prescient

seeds in John's imagination. "His classes and lectures were always spiced with

African wisdom. I'm sure he's responsible for part of my early interest in Africa. At

graduation, when he learned that I'd applied to Tuskegee to study steam heating

and plumbing and such, he suggested that I consider Hampton instead. 'It's a fine

school too and you'll meet more different people there, John.'"[15]

So in the fall of 1941, John Biggers entered college at Hampton Institute

in Hampton, Virginia, across the bay from Norfolk Naval Base. He did indeed

meet more different people than he had ever known before in his small world of

Gastonia and Lincoln Academy. Among them was an Austrian-Jewish art professor

who had fled Europe under persecution from Nazi Germany. John's counselor at

Lincoln had sent some of his drawings to the art department to help him get a

scholarship at Hampton. He didn't get the scholarship but the young artist came

to the attention of the professor, Dr. Viktor Lowenfeld. John was invited to join an

evening drawing class and soon changed his major from plumbing to art. "Before

I came to Hampton, I didn't know that art was self-expression, that one could

express his deepest feelings about anything, and that this was a legitimate and worthy thing to do."[16]

Dr. Lowenfeld often talked about his experience as a Jew undergoing persecution in war-torn Europe. His approach to teaching was challenging and emotional. He urged his students to discover and take delight in their own culture and emotions, rather than adapting a Western model. Because Christian missionaries had started Hampton, the institution had accumulated a fine collection of indigenous art from Africa and the Americas.

> *One day Lowenfeld took us to see the African art collection. He was trying to show us that we had something of our history in that little museum. But we were not sure of him, if he was being honest with us, you know? After all, the man was showing us an alien culture. We kids were products of slavery and segregation. But he said, "All of you must understand that when you get on a streetcar, it's segregated, but no one can segregate what's in your mind. I want you to express your feelings about your life."*[17]

John was profoundly affected by Lowenfeld's attention and passion, and vowed that his own art should be very strong, so that there would be no doubt as to what it was about. It wasn't long until John wrote to his mother to tell her he was going to change his major from plumbing to art. She agreed, saying that John should choose his own path. "I began to see art not primarily as an individual expression of talent, but as a responsibility, to reflect the spirit and style of the Negro people. It became an awesome responsibility to me, not a fun thing at all."[18]

Viktor Lowenfeld at Hampton Institute soon developed a national reputation. He brought Charles White, the muralist, and Elizabeth Catlett, the sculptor, to the campus to stimulate and inspire the young artists. From that class several other students along with John Biggers became professional artists and had life-long careers in art. Through his contacts, Lowenfeld was able to arrange a show of his

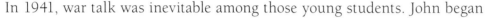

students' art at the new Museum of Modern Art in New York City in November 1943. The angry and expressionistic style of John Biggers's work did not resonate well with the critics of the day. That reaction discouraged John from ever considering the life of a New York artist, although later he did visit Charles White and Elizabeth Catlett who were then living there.

In 1941, war talk was inevitable among those young students. John began

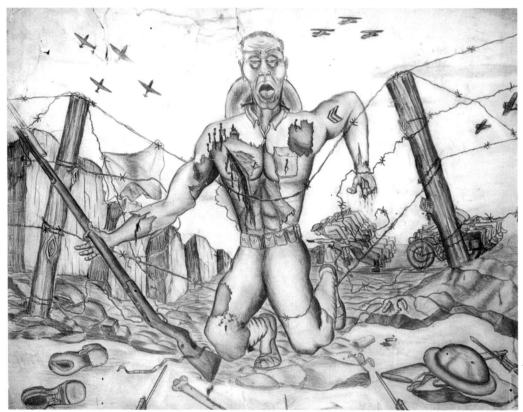

figure 2
Dying Soldier
Pencil on paper
1941–1942

to sketch his fears about the war. Lowenfeld gave him tracing paper, and showed John how to organize those drawings into his first major drawing, *The Dying Soldier* (fig. 2).

> *I started drawing what I felt had truly happened to all of us. We knew we'd be inducted, and nine chances out of ten, we'd never get back. Certainly all the freshmen men were all excited, knowing that they might be called up. None of us would ever finish college... that's what we all felt.*[19]

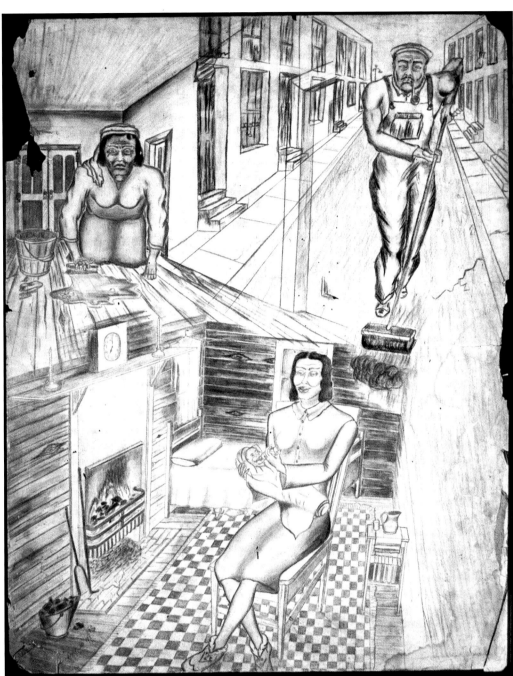

figure 3
Family
Pencil on paper
1941–1942

For John, this feeling became so serious that he had to express it. He started

drawing on cheap poster board because he didn't have any drawing paper. He

drew his family, a rape, a lynching, a crucifixion and more (fig. 3). He explained:

"This is what I imagined I'd think about if I were going to die. Imagine yourself a

victim of the war, segregation, and discrimination. I'd just be shot. But we were all

ready to defend the nation—we all were."[20]

Even without the drawing skills of a mature artist, the young Biggers conveyed the emotional intensity of fear and anger. His lack of knowledge of correct proportion and anatomy seemed obvious in these drawings, but the power was there. Those years of watching his big brothers model figures as they copied Petty Girl calendars is evident in his use of shading, which created the illusion of form on the flat paper.

The first several years at Hampton were happy and productive ones for John. His professor was determined to give his young art students a comprehensive education. Lowenfeld and his wife often invited students into their home for classical music, German food, and good philosophical conversation. His students grew to thrive on this rich full life and lived for their art. During that time John met a pretty young accounting major, Hazel Hales, and they became close friends. John talked and Hazel listened, encouraging him to pursue his dreams. Recalling their early friendship, Hazel says: "I had a boyfriend but I liked talking to John. We were good friends."[21]

The sketches that John made in preparation for his next large mural drawing in *Community Preacher* (fig. 4) are revealing of his thoughts. The church formed the center of the early Negro community life, and the preacher especially had real power as a source of righteous knowledge. But John's dreams, shown in these sketches, had to do with Africa (fig. 5).

Biggers commented on this mural drawing while perusing the major traveling retrospective of his work, *The Art of John Biggers: View from the Upper Room (1995–1997):* "The setting is a church where people express themselves without restrictions. The preacher is that man with the big fists, speaking with a cadence. He's talking about Africa that represents a search for the source. Where did we spring from, where did we come from?"[22] These early questions continued to intrigue and challenge John Biggers throughout his life.

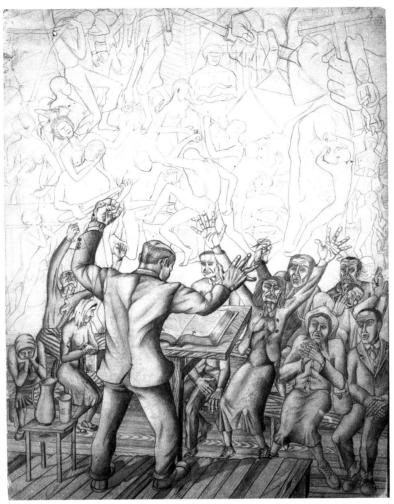

figure 4
Community Preacher
Pencil on paper
1943

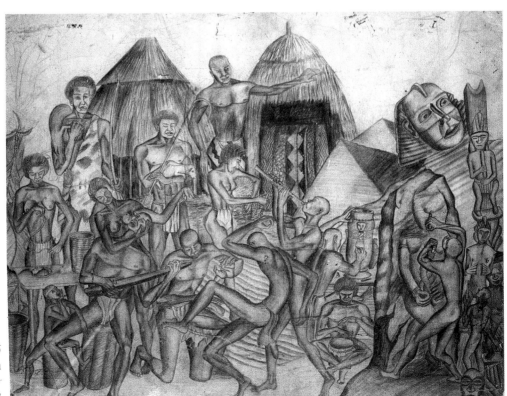

figure 5
Africa
Pencil on paper
1942-1943

Continuing with his reflections, Biggers observed that these questions remained without answers. He commented that all kids have these questions, but that his early teachers said that they just didn't have time to talk about such things. "That predicted my future, way back in 1943. In 1995 I'm still asking the same questions. In the fifties we started going to Africa; six-seven visits. I will never be able to find the answers. The quest itself is so full of excitement. Now I add some knowledge to the quest. Every work of African art in my collection is a way to approach this question."[23]

In his second year at Hampton, John was already recognized as an exceptionally talented artist. Under the guidance of sculptor Elizabeth Catlett, he had shown

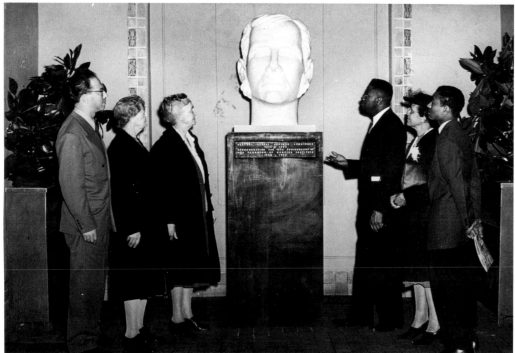

figure 6
General Armstrong
sculpture by John Biggers
1943

a gift for sculpture as well as painting and drawing. He was chosen to create a sculpture that would mark the seventy-fifth anniversary of Hampton Institute. Biggers sculpted a plaster bust of General Samuel Armstrong, the founder of Hampton (fig. 6). The event was recorded in this 1943 photograph. (From left to right, Viktor Lowenfeld, General Armstrong's daughter and wife, the bust of Armstrong, R. O'Hara Lanier, and Cora and John Biggers)

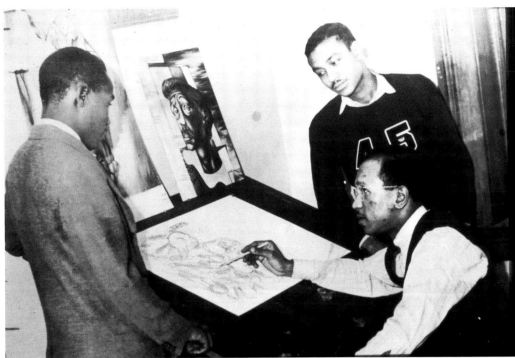

figure 7
Joe Mack, Charles White
at drawing board with
John Biggers

John apprenticed himself to Charles White, who had been brought to Hampton to paint a mural for the college. He learned a great deal about mural painting that he was to apply later on in his own work. Charles White was also a great draftsman and teacher for the young students. In this photograph (fig. 7), a fellow student, Joe Mack, is standing to the left; Charles White is in the center, and John Biggers to the right.

Throughout 1943 and 1944, Biggers kept a sketchbook that was recently rediscovered by his wife, Hazel. These small early 1943 sketches give some insight into his thoughts for future paintings and drawings. He had great respect for his mother's work at the ironing board and the wash tubs, doing laundry for others (fig. 8). This sketch gives a picture of his early home: clapboard walls, a fireplace for heat, kerosene lamp, a basket of ironing, and a heavy flatiron (no electric wiring) and ironing board, the laundrywoman's tools of the trade. Throughout his years, Biggers returned again and again to the struggle of making a living in poverty. He had seen so much suffering and endless pain in stoop labor. This study for *The Gleaners* (fig. 9) was one in a series of sketches on that theme.

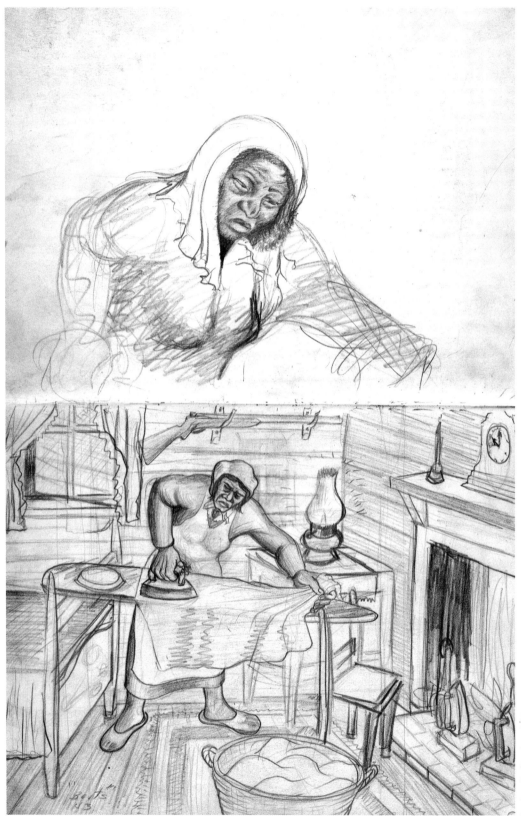

figure 8
Laundry Woman
Graphite on paper. 10 1/8
x 8 in., signed. Reproduced
courtesy of Michael
Rosenfeld Gallery, LLC,
New York

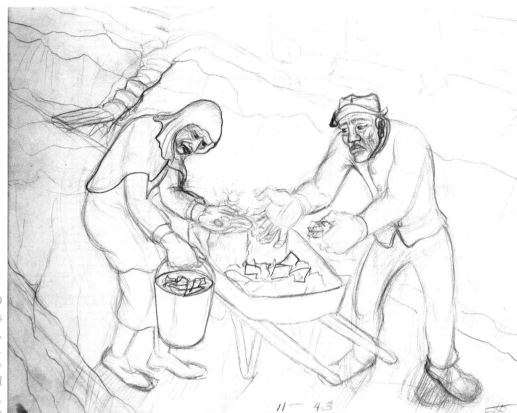

figure 9
Study for the Gleaners
*Graphite on paper,
10 1/8 x 8 in., signed.
Reproduced courtesy
of Michael Rosenfeld
Gallery, LLC,
New York*

World War II finally came to the Hampton campus in May 1943. John Biggers was drafted into the Navy Seabees and spent four months in basic training at the Great Lakes Naval Station in Illinois and took his sketchbook with him. After testing, he was sent back to Hampton to work on the construction of scale teaching models for military machinery. In the interim, Hampton Institute, on the Norfolk Bay, had become an adjunct to the Navy and the campus was overrun with black recruits and white officers marching everywhere. The officers, and even German POWs, had dining privileges in town that the black Hampton students and sailors were refused. Hampton began to bristle with angry feelings. This self-portrait (fig. 10), dated November 23, 1943, depicts a cynical and angry man. Surrounded by his art materials and canvas, his world had changed. The protected and encouraging atmosphere at Hampton had become racially charged with Jim Crow practices. Even though John was finally put to work painting murals and making

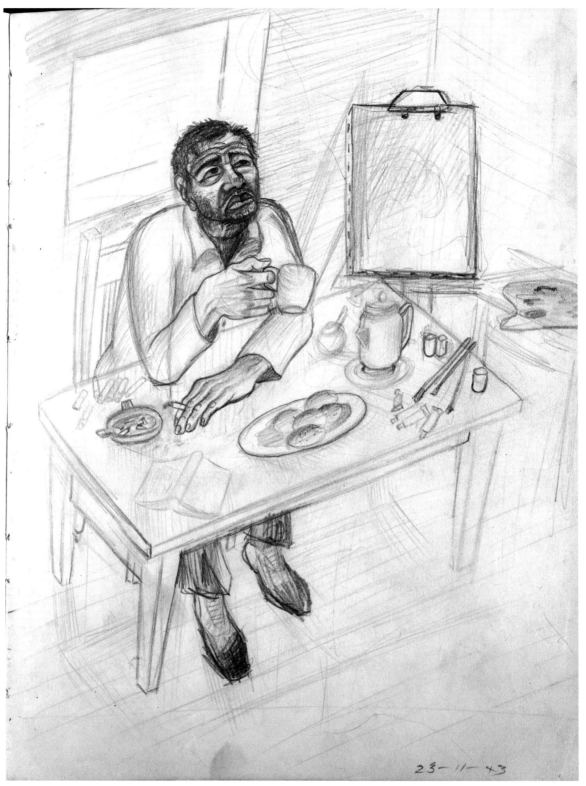

figure 10
Self Portrait
Graphite on paper.
10 ⅛" by 8"
Reproduced courtesy
of Michael Rosenfeld
Gallery, LLC, New York

instructional aids for teachers, his emotional health began to suffer. In January of 1945, he was shipped to the Norfolk Naval Base. [24]

> *Service was such a terrible experience. There was gambling all night, the Seabees were unloading live ammunition all night long. Live ammunition! On the weekend they would bring three or four prostitutes for those men. Terrible. Ambulances would come to carry the girls away. It was really terrible. We were right across the street from the US Naval Station Recreation Center and we couldn't go there. Segregation, you know. They would be out swimming, dancing. It was very frustrating and terribly demoralizing. But it was part of that very terrible time of segregation. During that same time I was trying to draw stuff.* [25]

The months on the naval base left John angry and depressed and eventually led to his hospitalization in a naval hospital in Philadelphia in October 1945. There a psychiatrist gave him pencils and paper and instructed him to draw. He recalled: "I drew that shit … I gave myself therapy … All that crap I was going through down there, I did some things that Pieter Bruegel and them hadn't done … I drew everything. I drew the whole damn mess." [26]

After drawing fiercely angry pictures for a month of therapy he was given an honorable discharge and returned to Hampton. Back on campus he learned that his mentor was leaving that summer to join the art education program at the Pennsylvania State University. John decided to follow his mentor to the northern university.

However, his education in the north became another lonely period in his life because he was one of just a few black students on the large campus. Pennsylvania seemed cold in both temperature and temperament to this quietly intense student from the South. Letters from Hazel (who had graduated and was now working at a college in Florida) and invitations from the Lowenfelds and other faculty members

kept John's spirits up throughout this time. He recalled that the registrar had befriended him and occasionally invited him to Sunday dinner with his family, which included his daughter and her boyfriend. "I was so grateful for those invitations … they meant a great deal to me." [27]

The education that John Biggers received from Viktor Lowenfeld was a rigorous one. Although Lowenfeld was best known for his unique understanding of how children developed cognitively in art, he was also a skilled artist himself and had been highly trained in European schools. He was determined to provide his students with the best possible art education. In his highly influential book, *Creative and Mental Growth* (1953), Lowenfeld asserted that there were two basic approaches to art: through the eyes (visual) and through feelings (haptic).

John recalled something Viktor had often said about figure drawing that was memorable to him: "To draw figures in motion, start with a three-minute pose, ask what part of the body is being used in carrying the weight, lifting, think, and then open your eyes. How does it feel when you lift? We couldn't copy visually, the form had to have depth and meaning. We should not be dependent on the visual but on feeling." [28] Biggers added: "The figure starts from the inside out. You get the shape for the figure first, and then put the clothes on." [29] The two following drawings are good examples of Biggers's clear approach to the form of the figure.

The memory of his own experience brought him to reflect on the injustices of the life of the sharecropper in the South. He saw that many families were doomed to a lifetime of hard labor and endless poverty. *Harvesters I* (1947) (fig. 11) eloquently depicts that reality. Working on brown cardboard with conté crayon and gouache, Biggers caught those exhausted workers in sculptural relief form, almost as if they had been fashioned from a sheet of copper. Those strong misshapen hands and feet speak of the pain and sorrow of the life of a subsistence farmer. One has only to look at media coverage reporting current areas of war, drought, floods, and famine to recognize the truth inherent in these drawings.

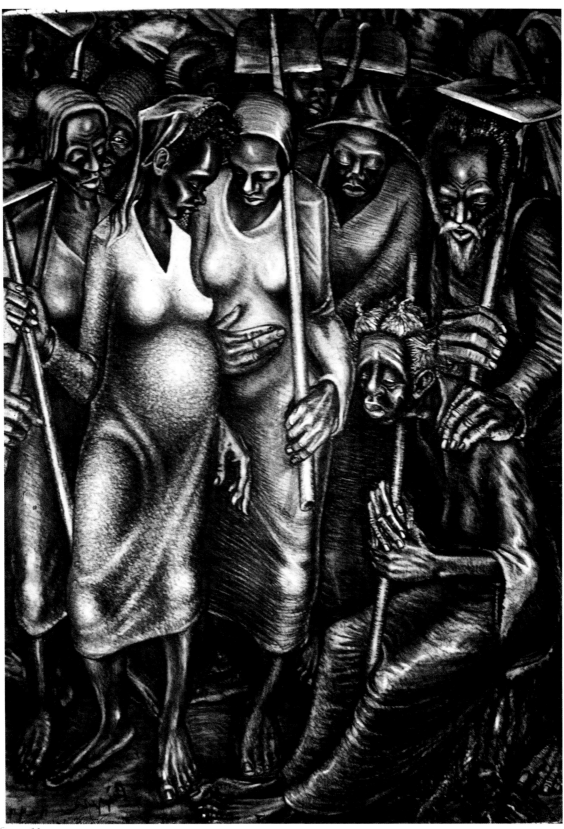

figure 11
Harvesters I
*Brown cardboard with conté
crayon and gouache
1947*

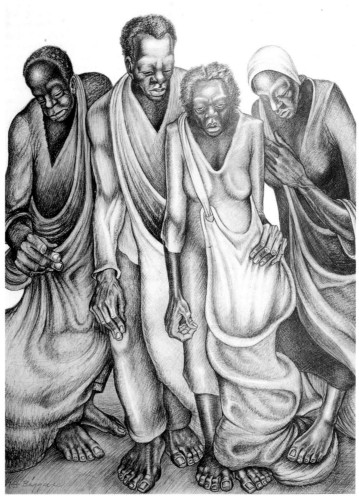

figure 12
The Cotton Pickers
Conté crayon on paper
1947

I'm trying to portray working people. I drew people I knew about.
I knew the characteristics of hard working people. Got a joy out of
making hands and feet large, even more than faces. Workers have
strong hands and bad feet. That's why my work emphasizes backs,
hands, and feet. I spent a good deal of time looking at the physiques of
people who had been doing hard labor. Lots of people became disgusted
with me, portraying this.[30]

The Cotton Pickers (1947) (fig. 12) similarly depicts a moving image showing
the effects of a lifetime spent picking cotton. This drawing too has a strong sculp-
tural quality, created by skillful cross contour lines with conté crayon and gouache
on brown board. Though anatomy and proportion do not yet reflect the classical
standards, the skillful use of chiaroscuro creates the feeling of sculptural form.

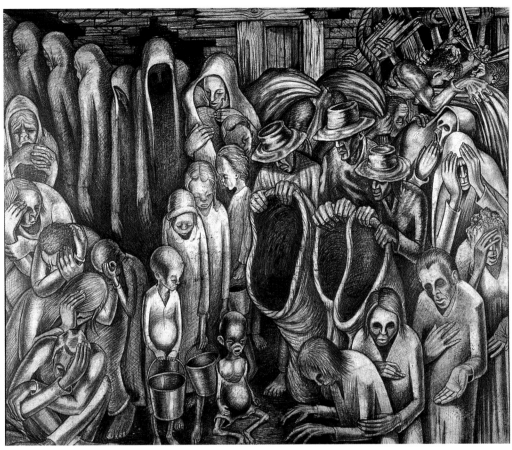

figure 13
Night of the Poor
Preparatory drawing
for mural, Pennsylvania
State University
1949

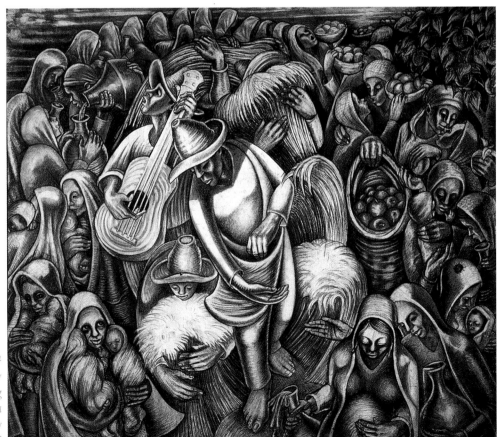

figure 14
Day of Plenty
Preparatory drawing
for mural, Pennsylvania
State University
1949

In his senior year, Biggers threw himself into his work with deep feeling and produced a series of powerful mural drawings: *Burial, Sharecroppers, Baptism, Night of the Poor*, and *Day of Plenty*. They were installed on the Penn State campus and later, some at the Hampton University Museum. Working drawings for *Day of Plenty* (1948–1949) and *Night of the Poor* (1948–1949) are shown in this section (fig. 13, 14). Both murals were planned to depict the value of education and were to hang in the Burrowes Building, the education building on the Penn State campus. The pencil drawing for *Night of the Poor* (1948–1949) was to emphasize the effect that a lack of education has upon the circumstances of poverty.

Day of Plenty (1948–1949) was intended to show the power of people who have learned, through education, to work together for the common good. The drawing also reflected John Biggers's discovery of Diego Rivera, whose work he admired greatly. "Here I am, at cold, wintry Penn State, working in the style of a Mexican painter. I was so influenced."[31] Those drawings reflect his passionate commitment to art expression as a response to the life he had known and cared about. The rituals of birth, life and death, regeneration, and hope had been at the core of his understanding of life.

The small pencil sketch, *First Shotgun Drawing* (1949) (fig. 15), was a prescient drawing. It was a preparation for an oil painting that Biggers was planning. Fifty years later, Biggers developed that motif into a spectacular series of works, believed by many to be the classic icon of African American life.[32]

Biggers completed the Bachelor of Science and Master of Science degrees by 1948 and in 1954, earned his Doctorate in Education from Penn State University. Meanwhile, the friendship of John Biggers and Hazel Hales had slowly blossomed into romance. On December 27, 1948, they were married, but did not share a home until John had completed his studies at Penn State in the spring. He had already decided that he wanted to return to the South rather than follow the crowds of starving artists flooding New York City at that time. Biggers commented: "I felt

figure 15
First "shotgun" house
drawing,
pencil on paper
preparation for painting
1949

that if I had anything to say, I would have to say it the South. When I left Penn State, I left intentionally. I wanted to come where I felt the black people's roots really are—and they are in the South." [33]

Before John Biggers left Penn State in the spring of 1949, he received a call from the dean of Texas State College for Negroes, a new institution in the state. The dean requested a work of art from Biggers for the opening of the Julius C. Hester House Community Center in Houston. Mrs. Susan McAshan, a significant donor to the center, sent a note to President R. O'Hara Lanier suggesting that they "should get that young man to come here to start their art department." [34] Soon after, President Lanier did offer John Biggers the position of initiating an art

department at the new college. And so the newlyweds, John and Hazel Biggers, began their move to hot and steamy Houston, Texas, by way of Alabama State University where he had a temporary summer teaching position during the summer of 1949. The pieces of the quilt were coming together.

Building in Houston and Texas Southern University, 1949–1957
ASSEMBLING THE QUILT

CHAPTER THREE

Following the temporary teaching position in the summer of 1949 at Alabama State University, John and Hazel Biggers moved west to their new frontier. John would be establishing an art department for the new Texas State College for Negroes. In 1949 Texas was still a segregated state with its own version of Jim Crow laws. Biggers had already begun to establish a reputation as a promising young artist, and some questioned the wisdom of accepting a position at a segregated school. Many in the black community believed that supporting such an institution would only perpetuate an untenable situation. Even John and Hazel's landlord, who had agreed to provide rooms for the young couple, was outraged. "How could you do it, John?" asked his angry landlord.[1]

John Biggers, however, had decided that an all-black college was exactly where he was most needed. He wanted to help young black college students develop an appreciation and acceptance of their heritage, believing that would result in a healthier view of the self. In 1949 the negative self-image for some in the Negro community was a serious societal problem, though seldom confronted openly. The Civil Rights Movement would address that issue in the next decade.

Voting rights, equal opportunity legislation, the Black Power movement, and Black History Month were solutions of the following decades.

This photograph (fig. 16) shows John Biggers in his office during 1950–1951 with some of his sculptures. Early in 1950, John organized a conference for art educators and invited Viktor Lowenfeld as a speaker. The following photograph (fig. 17) shows his colleague Joe Mack, Dr. Lowenfeld, and John Biggers at that time.

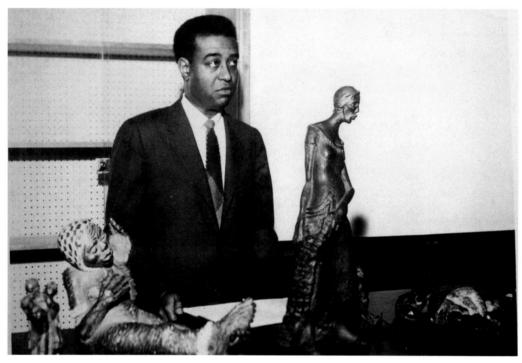

figure 16
John Biggers in his office
at Texas Southern, with
his sculptures
1950

President R. O'Hara Lanier of Texas State University for Negroes had been an administrator at Hampton Institute in the early 1940s. He had known of John Biggers's abilities. Lanier was eager to see an art department on his campus and promised his full support. He soon hired two more Hampton graduates: Joseph Mack, a painter, and Carroll Simms, a sculptor and potter. Hazel Biggers had graduated from Hampton with a degree in business and quickly found a position in the business office. The couple located a small two-room apartment of their own not too far from campus. The name of the institution was changed to Texas Southern University in 1951.

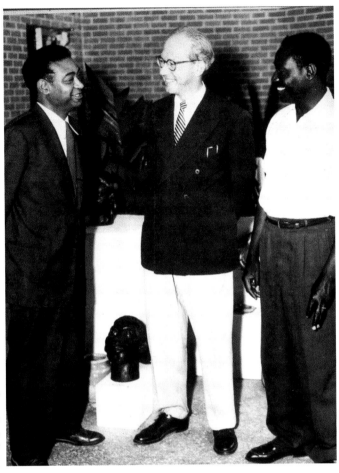

figure 17
Joe Mack, Viktor Lowenfeld,
John Biggers,
Texas Southern University
1951

It was not an easy beginning for the young couple who were new to Houston ways. Texas Southern was located in the Third Ward in Houston. Perhaps threatened by the influx of outsiders, residents resisted efforts by faculty members to find convenient housing in the immediate area. Several cross-burnings occurred on the lawns of those who succeeded in purchasing homes.[2] Thursdays had been reserved for Negroes who wished to visit the prestigious Houston Museum of Fine Art but there was no parking allowed downtown anywhere for Negroes. The college was near the downtown and museum district, but not within walking distance.

The space provided for this new department was woefully inadequate. Biggers described how he found his classroom. It was a room measuring about 18 by 25 feet, with only a clutter of poorly matched one-arm lecture chairs and nothing else. Both Hampton and Penn State had fairly well-equipped art studios for their students. Said the disappointed Biggers: "We didn't have one sheet of newsprint, not

one crayon, or tube of paint. No drawing stand or easel. No sculpture stands—no potter's wheels. We had to tell our few students that they must provide their own supplies."[3]

Biggers had ordered supplies and was assured that the order had been placed. Later he learned that all requisitions had been "lost" and never ordered. But despite his anger, discouragement, and disappointment, he was determined to build a good art department. First, though, he needed students. Biggers wryly recalled those recruitment beginnings: "I'll never forget the way we had to get students to come to Texas Southern. Jim Dorsey, the fine arts department head, would take a choir of about sixteen students, six actors, and a few dancers. Joe Mack and I would get on that bus and go from town to town."[4]

The recruiting bus went all over Texas. They'd meet at some church, the choir would sing, the dancers would dance, and Joe and John would talk to students about art. The two would set up easels, paint a little, and talk some more about art. Finally, they went to the Houston Public Schools, offering art education classes for teachers, and then things began to take off for the art department at TSU.

Biggers, Simms, and Mack were asked to use their art skills to brighten up a new nursing home in the area, the Eliza Johnson Home for Aged Negroes. John drew a series of drawings for murals depicting small-town life (fig. 18). These drawings represented a change in mood in John Biggers's drawings. They were

figure 18
Negro Folkways,
Eliza Johnson Home for
Aged Negros
1950

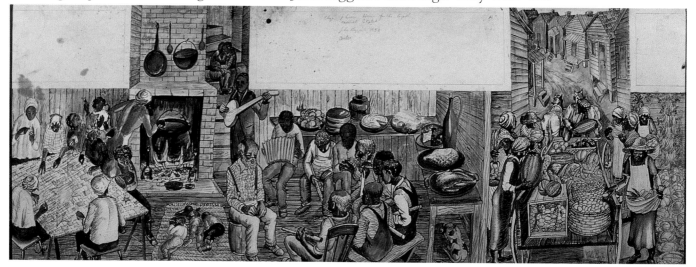

lighter and brighter, far more nostalgic than despairing. "I hoped that … the murals and sculpture would give the elders moments of nostalgia—moments to reminisce and to share peaceful days."[5]

Involved as Biggers was in setting up this new department, teaching classes, and planning the murals, he had little time to draw. So Biggers would join his students in class or in the kitchen when Hazel was cooking supper. While guiding a visitor through his 1995 retrospective exhibition at the Museum of Fine Arts, Houston, he gestured towards several early drawings:

> *The first two drawings I made in Houston were those two:* The Cradle *and* Sleeping Boy. *The reason they are so important to me is that I don't think I've ever beat them. I haven't done anything that has more strength, or drawing quality.*[6]

The Cradle (fig. 19, and also featured on the jacket to this book) was entered into the annual 1950 Houston Artists Exhibition sponsored by the Museum of Fine Arts of Houston. One day the dean received a message from the museum stating that their new faculty member had just won their Purchase Award. The museum director then told John that because of segregation they would have to celebrate separately or lose the opportunity to desegregate the museum entirely. He invited John to come down to the museum that Thursday evening for their champagne party to view the exhibit and receive his award. Dr. Chillman, the museum director, then promised John: "'if you will do this thing, I guarantee there will be no segregation at this museum next year.' And, that is what happened. The museum was desegregated, just as he'd promised, and we've been friends ever since."[7]

And in 1995, the Museum of Fine Arts, Houston, mounted the largest and most important retrospective of John Biggers's work. The exhibition traveled from 1995 to 1997 through five venues, drawing large crowds at each stop. Thinking about the prize-winning drawing, *The Cradle*, Biggers reflected:

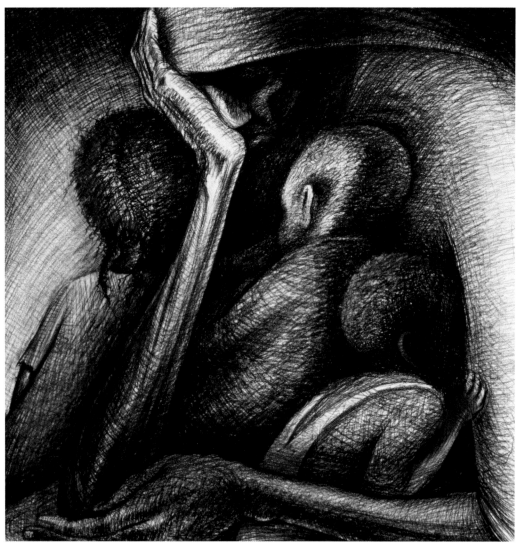

figure 19
The Cradle
carbon pencil on paper
Museum of Fine Arts of
Houston, purchase prize
1950

You know, The Cradle started my career in Texas. We had a two-room apartment, two straight chairs. One I sat in, the other I put the drawing on. I inhaled the cooking smells, the odors that all stimulate my thinking. I never conceived an idea in the studio. I have a fragile drawing program, elicited by the sounds and smells of domestic life. No cold engineering setup for me. I interpreted drawing as the domestic side of life. For me to draw while Hazel is peeling an onion, cutting up okra, that is a wonderful part of existence.[8]

John Biggers often produced a number of drawings on the same theme. As an example, this drawing (fig. 20), also titled *The Cradle*, was kept in his personal

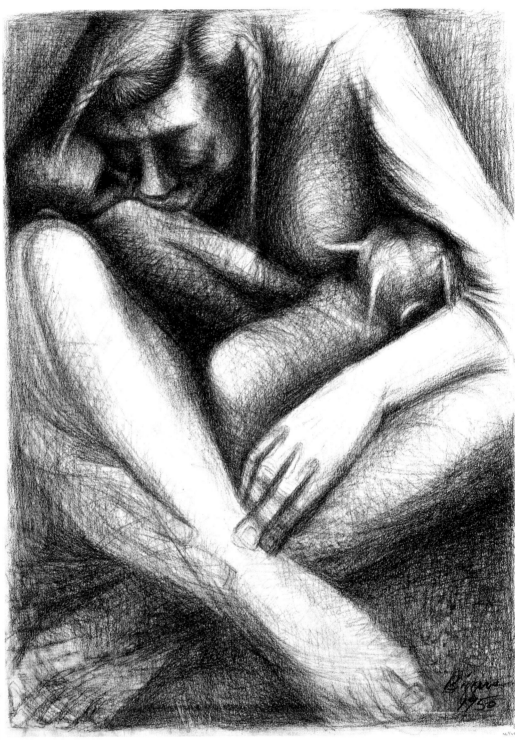

figure 20
The Cradle
Charcoal on paper,
30 x 22 in., signed.
Reproduced courtesy of
Michael Rosenfeld Gallery,
LLC, New York

collection. It is signed and dated 1950, and has been very seldom shown. We might

guess that this drawing followed the prize-winning drawing. Perhaps this was a

replacement for the one kept by the museum for the purchase prize. Our eyes are

drawn to the infant burrowing into the safety of the mother's arm. The warmth and

tenderness expressed in these two drawings are unequalled in his works on love.

Drawing was an innate part of John Biggers, a necessary part of his daily life. "Painting and drawing to me are just as important as eating, making love, or anything. It's a biological, spiritual thing. I can't separate it."[9]

Biggers worked primarily with basic materials such as crayon and pencil. This was an era when most artists were involved with media experimentation and used a wide variety of drawing tools and techniques. This artist, however, found what he liked and stayed with it. He worked first with lead pencil, then Wolff charcoal pencil, and finally conté. He observed that charcoal just flew away from him and that artists who use charcoal have to learn to use the smear.

Even the paper to be used in drawing was a matter for consideration, the artist noted: "In London, at the Victoria and Albert, I saw a Leonardo drawing of Mary, Jesus and St. John, on stained meat market paper. I said then that I'd never buy expensive paper again. This convinced me that one could use common materials to draw." [10]

As if to emphasize his point, he noted that *Harvesters* (1947) was drawn on brown cardboard. He noted that he had started with soft lead pencils, but finally found conté, which was much more solid. Biggers observed: "When you make a hard line, it would stick. Conté sticks did the trick. When you work with the stick pressed in, you always have a sharp point. Sharpening a pencil, you waste all the lead. For years I used the mat knife and razor blade, cut only the wood, not the lead. Now I'm back with conté sticks."[11]

In 1952, John submitted another drawing to the fifth Southwestern Exhibition of Prints and Drawings, sponsored by the Dallas Museum of Fine Arts. Once again, he received a letter informing him that his drawing, *Sleeping Boy* (1952) (fig. 21)[12] had won the Neiman-Marcus Prize for drawing, and was invited to Dallas to accept the award the following Sunday at the museum. John and Hazel drove up from Houston, but upon meeting the couple, the committee quickly presented the award to John in the parking lot. Again the practice of

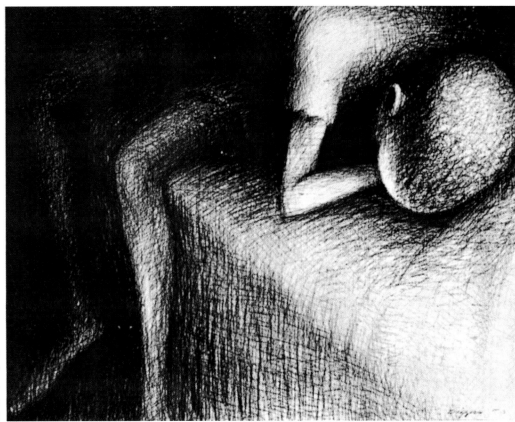

figure 21
Sleeping Boy
Carbon pencil on paper
Cover, DMFA Neiman-
Marcus Purchase Prize
1952

segregation had reared its ugly head. It was not long after that the Dallas Museum of Fine Arts also was desegregated.[13]

Biggers described how he had happened to draw *Sleeping Boy* (1952):

Sleeping Boy *was drawn in the doctor's office on a scrap of paper.*
I had carried my mama to the doctor's office, was waiting there, saw a
little child asleep on a chair, sketched him on a scrap of paper. When
we got home, I immediately transferred the sketch to a large sheet. [14]

1952 was a significant year for John Biggers. Biggers had been approached by Rev. Fred T. Lee to do a memorial project for his wife, this time for the Blue Triangle Branch of the YWCA, located several blocks from the Texas Southern University campus. Biggers suggested a mural based on the idea of a black matriarchal image depicting the heroic role of black women in society. Although funding was short, Biggers and Lee agreed to the project and began to research the lives of great black

women. He selected Harriet Tubman, Sojourner Truth, and Phillis Wheatley to be the major subjects and began to read about these path-breaking women.[15]

Meanwhile, he and Hazel had made plans to go to the University of Southern California for a summer session to study lithography and etching with Dr. Jules Heller, the noted printmaker. "I wanted to do lithography because of drawing. Back then I had an urge to be a great illustrator, and illustrate with lithography. That's why I went to study with Heller."[16]

Lithography proved to be a natural medium for the artist. The medium has a very physical aspect. He found drawing on stone in some ways similar to sculpture, which he loved. Lithography is a complex print process that involves preparing a flat rectangular stone, grinding the surface smooth, drawing on the stone with a litho crayon, creating highlights by scraping or cutting, etching the drawing with acid, then inking the stone with a roller, and finally taking a print. The first print is called a proof print, and it is from that proof that the artist determines any further changes to be made. Said Biggers in *Black Art in Houston* (1978): "Becoming a successful printmaker, as I saw it, required some combination of artist, scientist and agile workman. I felt that I was endowed with those three qualities. And I loved to smell the odors of turpentine, ink and acids."[17]

In addition to many sketches for his mural, Biggers produced a portfolio of drawings, lithographs, and etchings during that summer. Among them were *Two Heads: Mothers* (1952) (fig. 22), *Matriarch* (1952) (fig. 23), *Frustration/Despair* (1952) (fig. 24), *Harvesters II* (1952) (fig. 25), and *Harvesters III* (1952) (fig. 26).

In *Frustration/Despair* (1952), there is an echo of the despair expressed in *Harvesters* (1947) and the *Cotton Pickers* (1947) (discussed in Chapter Two), combined with the broad gestural quality of *The Cradle* (1950) and *Sleeping Boy* (1952). Biggers used the surface of a lithograph stone as drawing paper. An interesting mistake, common to most beginning student printmakers, is that his signature printed in reverse. Biggers had signed and dated the lithographic stone, rather

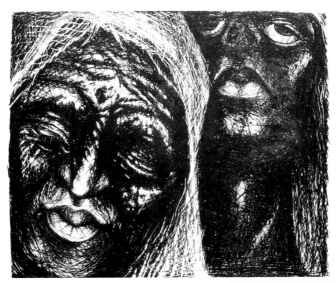

figure 22
Two Heads: Mothers
Lithograph
1952

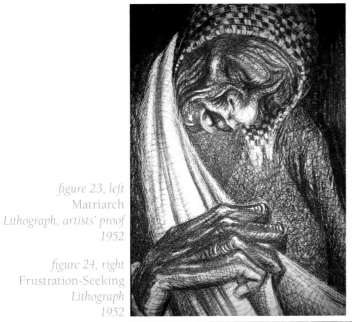

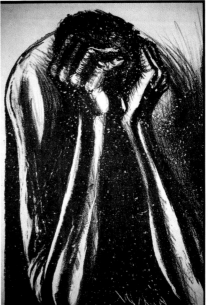

figure 23, left
Matriarch
Lithograph, artists' proof
1952

figure 24, right
Frustration-Seeking
Lithograph
1952

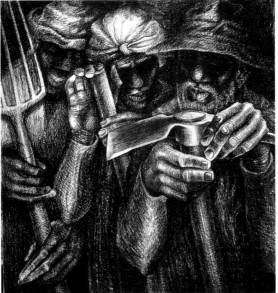

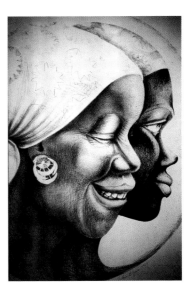

figure 25, left
Harvesters II
Conté crayon on paper
1952

figure 26, right
Harvesters III
Conté crayon on paper
1952

than waiting to do so on the prints. He resolved that issue by correctly signing and dating each print again as it came off the press. *Matriarch* (1952) *and Two Heads: Mothers* (1952) explore the strong black matriarchal image. *Matriarch* (1952) was a two-color lithograph with the headscarf and lips printed in a clear red. In these lithographs, Biggers utilized his signature technique of cross-hatching with linear detail to build the form in light and dark. This technique was well suited to the lithographic and etching processes.

Harvesters II (1952) and *Harvesters III* (1952) are two different works that bear the same title. *Harvesters II* (1952), is a masterful drawing of exhausted field workers. Biggers's use of cross-hatching strokes presents a fuller, more mature set of figures, compared to his 1947 drawing, *Harvesters. Harvesters III* (1952) is quite different in style: smiling women, bold, hard-edged and linear. It was developed as a lithograph. One gets the feeling that the harvest is finished and a celebration is in order.

Biggers immersed himself in lithography, but a surprise visit from his mentor brought about yet another development in his career. "Viktor (Lowenfeld) and his wife Gretl came out to see us during the summer. I showed Viktor all my research cards for the Blue Triangle Y project. He looked through everything excitedly and said, 'Man, you could use this project for your doctoral dissertation!' Right away I began sketching on the back of an envelope in that restaurant (fig. 27), and that's how I began to work on my doctorate at Penn State."[18]

He was reluctant to consider working on a higher degree because he felt that he had so much to learn in the studio area of art. But Biggers listened as Lowenfeld pointed out that he would need the authority and freedom that the doctoral degree would give him. Recalling all the disappointments with administrative promises made for his art program, John decided to enter the program.

At Lowenfeld's suggestion, John saved every scrap, every drawing relating to the development of his mural for the Blue Triangle YWCA. As a result, there is a

figure 27
First sketch for
Contribution of Negro
Women to American
Life and Education, *Blue*
Triangle YWCA
Pencil on paper envelope,
1952–53

graphic record of John Biggers's drawing process as he developed his ideas. Beginning with the envelope back on which he scribbled his first ideas, we can see his tentative marks as he developed his characters in quick gestures (fig. 27, 28, 29, 30) and laid out the overall composition, beginning with Harriet Tubman and the slave (fig. 31). From initial scribbles and gestures, the figures were given form and character through the contrasts of light and dark values. The overall layout was finally outlined in bold lines.

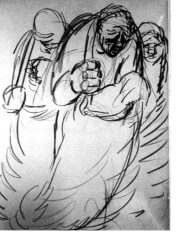

figure 28, top left
Shotgun homes
Pencil on paper
Blue Triangle YWCA mural
1952–53

figure 29, top right
Harriet Tubman
Preliminary gesture sketch
Pencil on paper
Blue Triangle YWCA mural
1952

figure 30, bottom right
Workers, Carrying Cotton
Gesture sketch
Pencil on paper
Blue Triangle YWCA mural
1953

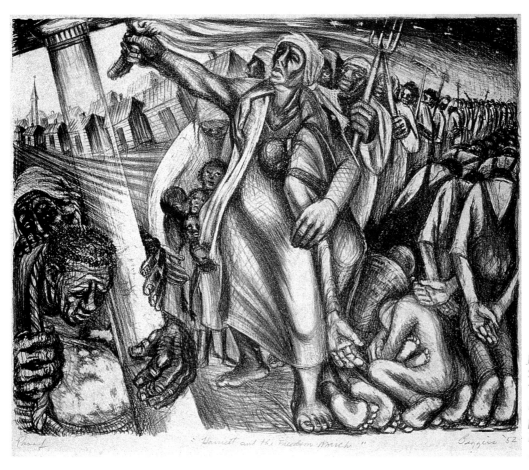

This drawing was enlarged on a grid. Biggers refined the lines and transferred them to a prepared wall. Then he developed forms with the addition of darker lines and spaces. Only after most the dark values were established did Biggers begin to apply color in small crosshatched brush strokes. Some of the main characters became subjects for lithographic drawings.

The final composition for *The Contribution of Negro Women to American Life and Education* (1954) (fig. 32) was intense and complex, with a complementary color scheme from orange to blue and a heavy emphasis on muted neutral brown tones. In addition to his main characters, Biggers had packed many stories into a wall 8 feet by 24 feet. A close look at the details introduces images that will reappear literally or symbolically in later work. Look for the drawing of the two in the center, the young man and old man (fig. 33). That pair reappears in a later mural, *The History of Negro Education in Morris County* (1955) (fig. 34) and the lithograph, *The Word*

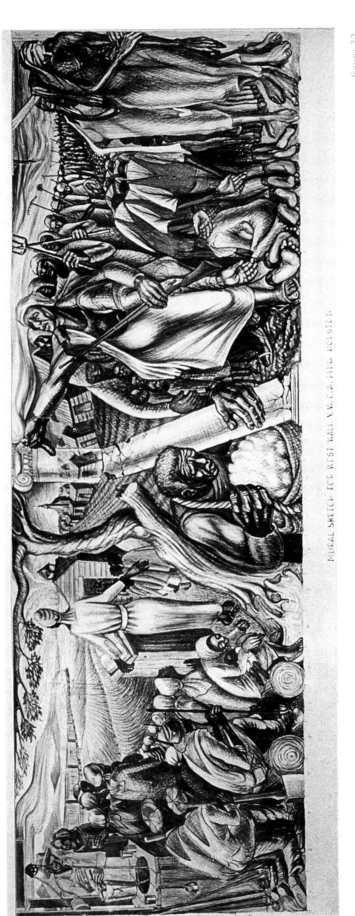

figure 32
Contribution of Negro
Women to American Life and
Education
Completed mural drawing
Color sketch, conté crayon,
tempera on paper
1953

(1965) (fig. 50, page 67). In the finished drawing, make note of the railroad tracks, the shotgun shacks, the woman quilting, the excessively large hands and feet, the bare soles, and the backs of men in overalls. Each of these images later assumed importance in Biggers's developing iconography.

Teaching at Texas Southern, spending six months at Penn State, and completing the mural project for the Blue Triangle YWCA enabled John Biggers to earn the Doctorate in Education from Pennsylvania State University in 1954. At Lowenfeld's urging, Biggers presented his thesis in open forum with slide documentation with the Dean of the College of Education, the Dean of the Graduate School, the Executive Committee of the Graduate School, and the President of the University, Milton Eisenhower, in attendance. This unusual innovation had an effect on other arts doctoral programs, such as Texas Tech University.

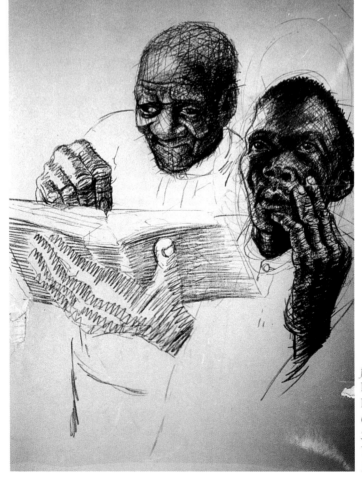

figure 33
Education,
Reading the Bible
Conté crayon on paper
Study for Blue Triangle
YWCA mural
1954

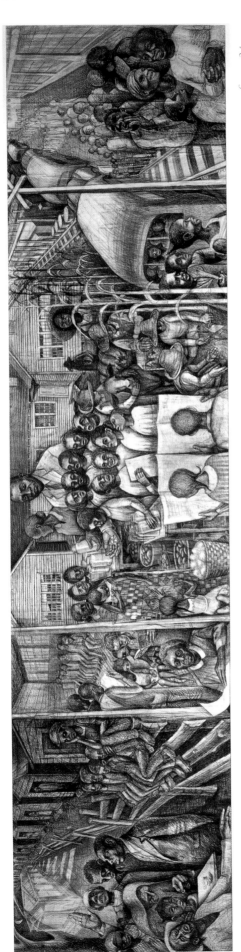

figure 34
The History of Negro Education in
Morris County
*Conté crayon and gouache on paper
(mounted to second piece of paper
mounted on linen).
31 ½ x 130 ¼ in., signed.
Reproduced courtesy of Michael
Rosenfeld Gallery, LLC, New York
1955*

The reputation of the Texas Southern University Art Department grew rapidly as did John's career as an artist. Two more mural commissions came his way. The first was in northeast Texas. The Naples, Texas, school board asked him to paint a mural illustrating the *History of Negro Education in Morris County* (1955) (fig. 34). That mural celebrated the opening of the first black high school in that county, the first school bus, and the retirement of the founding principal/teacher, Mr. P. Y. Gray. The second came in 1957, delineating the history of the local Longshoremen's Union. In both cases, John continued to use his singularly distinctive technique, applying tiny brushstrokes of paint in cross-hatching drawing strokes that slowly build form from the flat surface.

During this same time, John met a well-known folklorist who collected old Negro folk tales, J. Mason Brewer. With his guitar, Brewer sang folk songs, told stories in vernacular dialect, and gave lectures about those old tales. Mason asked Biggers to illustrate a book he had written that included some of those old stories, *Aunt Dicy Tales, Snuff Dipping Tales of the Texas Negro* (1953). Adjusting his style to a lighter, more comic vein while utilizing his dense crosshatching with deep shadows, Biggers produced fifteen full-sheet lithograph/pencil drawings that caught the determined spirit of the indomitable heroine, Aunt Dicy Johnson of Burleson County, Texas. *Dime Box Story* (1953) (fig. 35)[19] is one example of the illustrations in that little book, published by the University of Texas Press in 1953. Biggers's illustrations for *Aunt Dicy* were republished by the Harry Ransom Humanities Research Center in 1999. Biggers greatly enjoyed working with Brewer and described the experience:

> *Brewer was such a marvelous storyteller. He became each of the characters when he'd tell the story. He had a lecture circuit, wrote in the dialect. He never forgot any dialect he heard. I went with him one time. We stopped for a Coke and he showed me how he got his stories. People were telling jokes and they told us one and then we went on.*

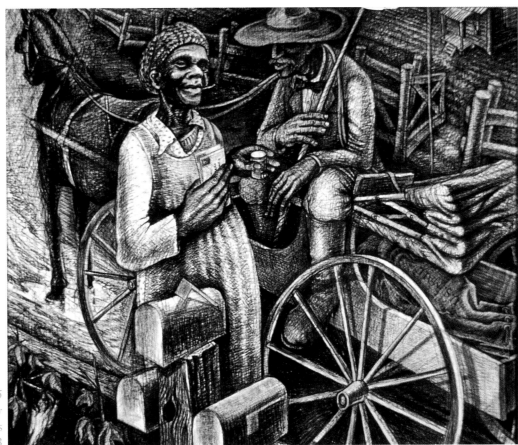

figure 35
Dime Box Story
from Aunt Dicy Tales
1953

When we were going on down the road, he started recalling what each

person said, and the dialect he spoke. No tape recorder. Just memory.

Amazing. [20]

Five years later, the University of Texas Press published another collaboration

between Brewer and Biggers, *Dog Ghosts* (1958). According Brewer, the "dog spirit"

tale is not a part of any oral tradition in America except that of the Negro. He sug-

gested that its prevalence among that group might be explained by the widespread

African myth that told how the dog became a friend to man, helping him to catch

his food, showing him the ways of the wild beasts, and asking only a place by

man's hearth and bones from his meals. Brewer asserted that the dog is a benign

ghost who appeared only to help someone in distress.[21]

Perhaps the dog ghost reappeared some forty years to rescue several of those drawings. In the late 1990s, Dr. Jean Andrews presented three of the *Dog Ghosts* (1958) drawings to the University of North Texas School of Visual Arts with the understanding that they would be restored, framed, and hung. The drawings had not been stored well so they needed restoration. Apparently, Brewer had given those drawings to a fellow historian, because the mats were inscribed in that way. The recipient, though listed in the *Dog Ghosts* book preface as one of many supporters of the Brewer project, apparently had little or no appreciation of the value of the drawings. They were large, drawn on 19-inch by 26-inch sheets with conté crayon, but were stored in a cardboard box in a garage for years.[22] However, Dr. Andrews recognized the works as being by John Biggers, understood their significance, and donated the drawings to the School of Visual Arts at the University of North Texas, in Denton. They have been restored and framed and are now on display in the office of the Dean of the School of Visual Arts.

Here are some of those *Dog Ghosts* (1958) tales. *Uncle Henry and the Dog Ghost* (1958) (fig. 36) introduced the dog ghost. In a vernacular style reminiscent of Zora Neale Hurston, the reader learns of Uncle Henry Bailey, baseball fan, who left Clarksville to go to a big ball game down in Oak Grove. The game lasted so long that Uncle Henry missed the last train back to Clarksville, and he had to walk home, through the black dark night, on the railroad tracks. To make a lantern, he picked up a Coca-Cola bottle, filled it with kerosene and stuck in his necktie as a wick. But on the way, he came upon a great white red-eyed dog ghost. Terrified, he dropped his lantern, ran home, stumbling through the darkness. His wife was not sympathetic and laughed at him, saying that he shouldn't have been scared because that dog spirit was just some good Christian friend come back from the grave to protect him on the way home. But Uncle Henry never left home after dark again.[23]

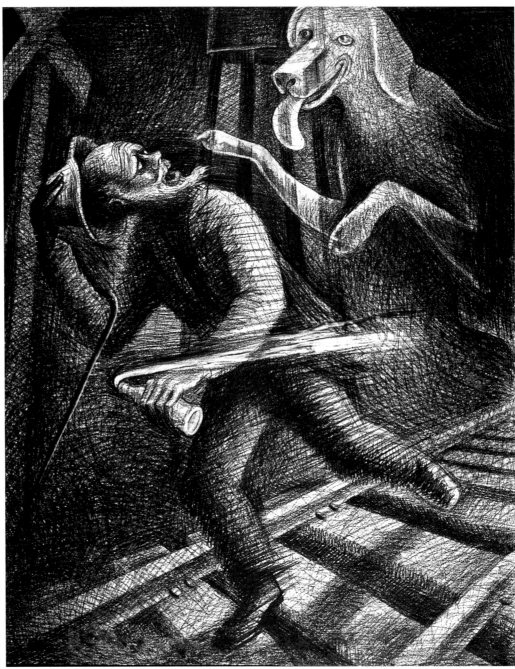

figure 36
Uncle Henry and the
Dog Ghost
from Dog Ghosts
Conté crayon on paper
1958

Uncle Aaron Peddles a Possum (fig. 37) (also called *Uncle Aaron Stops the Train*) illustrated a key element of many of these stories: that of poking gentle fun at the foibles of one another. The narrative was about an Uncle Aaron who lived on a little farm right at the railroad crossing where the trains always had to slow down. He concluded that he was in a good spot to do business with the trainmen, so one day, he waved a red bandana over his head and stopped the train. "You wanna buy a possum?" Uncle Aaron asked. The engineer angrily ordered him off the tracks but the conductor wanted to know how much he wanted for a possum. Shamefacedly, Uncle Aaron replied that he didn't know. "I ain't caught him yet." In a touch of humor, Biggers placed a nest of little possums peeking down from their perch above in a tree branch.[24]

Elder Brown's False Teeth (fig. 38) was a story that attacked unappreciated pretension with gentle ridicule. The uppity Elder Brown's false teeth dropped in the river in the course of an enthusiastic baptism. Not wanting the congregation to know that he had false teeth, the elder returned later to search for his missing dentures. Finally a young boy came by, hooked a chicken leg on a fishing line and threw it into the water. Amazingly, the dentures leaped right out of the water to snatch the drumstick tantalizingly suspended over the spot where the teeth had fallen![25] Of these stories, Biggers remarked: "Those tales have passed away now. Nobody wants to talk about that anymore … but what's wrong with our folklore? It's a part of us."[26]

Dreaming of Africa when he was young, Biggers applied for a UNESCO fellowship in 1955 to make such a trip. The colonial era in Africa was ending, and the United Nations program was interested in having traditional life and culture in Africa recorded. After two years with no word, UNESCO suddenly approved the fellowship. They were notified that they had two months to prepare for their six-month visit. John and Hazel Biggers were to be in Ghana by July 1, 1957. In April 1957, that country had just been granted independence by the diminishing British Empire.

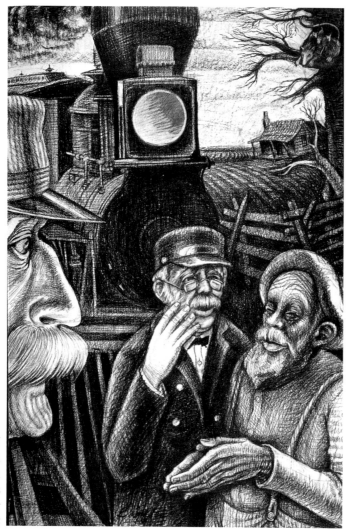

figure 37
Uncle Aaron
Peddles a Possum
from Dog Ghosts
Conté crayon on paper
1958

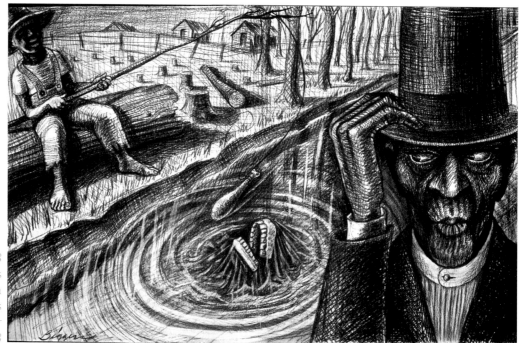

figure 38
Elder Brown's
False Teeth
from Dog Ghosts
Conté crayon on paper
1958

A few problems still needed to be solved. His contracted mural for Longshore-men's Union Local 872 (1957) was not yet finished, and the architect reneged on his promise to pay John for the work. The commission was to have paid for living expenses for the trip. So he worked day and night, completed the mural and then made his expenses by selling the working drawings to a serious collector of his work.[27] And then, by the first of July, Hazel and John were in the air on their way to the long-dreamed-of old world, and a new way of thinking about the continent of Africa and their roots.

Africa and Post-Africa: 1957–1974
FINDING THE MISSING PIECES

CHAPTER FOUR

*I*deas for drawings originate from many sources, just as do pieces of a quilt. They might emerge from the depths of an artist's emotional memories and fantasies or from a draftsman's powers of observation. The drawings that have been selected for the past three chapters have been expressionistic, emotional, and have come from inner memory as much as a reporter's observations. Throughout the first several decades of his career, Biggers's images were deep and somber impressions of the downtrodden, tragic expressions of the human condition. When asked about this characteristic feature of his early work, Biggers explained that he felt that it was absolutely necessary to show his feelings about what happens to people in poverty. "This to me is what art is all about—showing the spirit of man struggling above the mundane, above the material, above suffering."[1]

The influence of Viktor Lowenfeld can perhaps be understood by reviewing Lowenfeld's concept of *haptic* and *visual* approaches to drawing and painting: *Visual* artists use their eyes first, focusing on accuracy of visual perceptions. *Haptic* artists respond to visual stimuli with their feelings. Because John focused so strongly on the emotional quality of his work, Lowenfeld was convinced that

Biggers was a natural *haptic* artist who perceived with his feelings. He encouraged the young artist to find his own way, regardless of differences from the other students. Biggers recalled an incident as a student at Hampton in which he was trying to paint like those he admired. "Viktor said that I didn't have to paint like the others, that I was painting from my feelings, as a *haptic*. It's important to know what you are … Some days I am more visual than other days … for some people, the eyes are the real vehicles. For others, feeling is everything."[2]

The trip to Africa from July through December 1957 transformed Biggers's work. While the emotional content was still important, the drawings became lighter, brighter, and more visual as he drank in the spirit of the newly independent land. The resulting drawings were sensitively realistic in tone, rather than sorrowfully expressionistic. His fellowship from UNESCO was awarded to study the traditional life in Ghana and Nigeria and record his observations, and this certainly suggested a different approach to Biggers. Though the continent of Africa had been an active part of his imagination for some time, the reality was overwhelming to him, far beyond his expectations. He strengthened his skills of observation with on-site drawing, journals, and photographs, recording what he saw. Several experiences impressed him greatly. As he drew people, he was often reminded of the faces that he knew from home. But in Ghanan people, he also found great dignity, strength, and maturity of character in those he encountered. The personalities, he noted, seemed different from some at home. In his 1962 book, *Ananse: The Web of Life in Africa*, the record of his African trip, he observed that at home he had been accustomed to living among "inhibited people and warped personalities."[3]

In 1957, the journey to Africa was a remarkable undertaking for a young black couple from the United States. At the time of their first trip, few black Americans had traveled to Ghana. Because the former Gold Coast, now Ghana, was an early slave transport state, even fewer chose to visit that area. Alex Haley's powerful book *Roots* had not yet been written and would not be published for twenty

years. How prescient John Biggers had been to seek his African roots in 1957. He and Hazel returned to Africa three more times over the years. The artist spent the rest of his life blending his understanding of Africa into his art and beliefs.

The first stop of the journey was Accra, the capital of Ghana. From there John and Hazel were taken to the College of Technology, near Kumasi, Ghana. Their first host was Patrick Hulede, a member of the art faculty. Biggers was struck by the secure confidence expressed by African men and the central strength of the matriarchal spirit as the mother of mankind, expressed in the word *maame*. This drawing of a strong-jawed Patrick Hulede and his vibrantly erect mother (fig. 39) embodies that strength. From the College of Technology, they traveled to the Cape

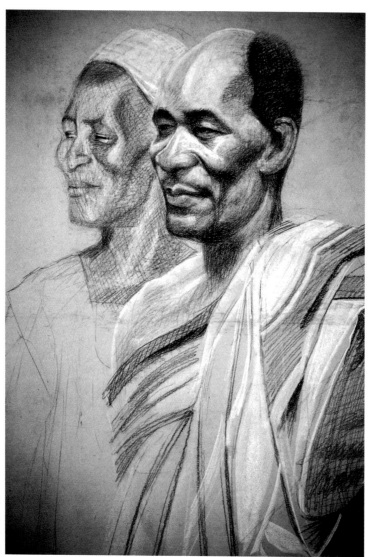

figure 39
Mother and Son
Conté crayon on paper
1959

coast on the Gulf of Guinea. Driving through the forests of Ghana, John drew some of the amazing tree forms from observation (fig. 40 and 41) The Biggerses were surprised by the appearance of Egyptian-like obelisks (fig. 42) similar to the structures Biggers had studied in art history. Farmers were working the cocoa farms (fig. 43). When reaching the ocean, they observed great drama in the life of the people dependent on the sea for their livelihood (fig. 44). The image of mother as sustainer of life imbedded itself deeply in Biggers's consciousness (fig. 45). Women were at work in the fields together, stripped to the waist and sweating from their labors in the tropical climate. Biggers later learned that women only undressed in that way when unaccompanied by men (fig. 46). Priests from Ilobu, Nigeria, greeted the couple's traveling party with drumming and dancing (fig. 47). His Highness, the Timi of Ede, greeted the Biggerses "not as foreigners, but as brothers who have returned home after an absence of three hundred years."[4]

These eight drawings, selected images from *Ananse*, revealed a different dimension of John Biggers's artistic development. These conté crayon drawings were fairly large, ranging from 15 by 20 inches to 40 by 60 inches. In some, charcoal or pencil was used with the basic conté crayon. Others were drawn with a range of conté sticks, black, white, and sienna. All were rendered in his signature technique, distinctive crosshatching and cross-contour stroking. Any difficulties that he may have had earlier with anatomical proportion had long since been corrected. He observed the life of real people in the villages with clear and sensitive eyes, demonstrating a sense of beauty and dignity of form in the young and the old alike.

Returning home proved to be difficult for John Biggers. The experience of traveling throughout West Africa had been totally overwhelming. Depicting the six-month journey and responding to its effect on him seemed nearly impossible. "Settling down to interpreting African life was the most difficult task I had encountered during my eighteen years of painting and drawing. The impact of Africa almost paralyzed my creative efforts; the drama and the poetic beauty were devastating…"[5]

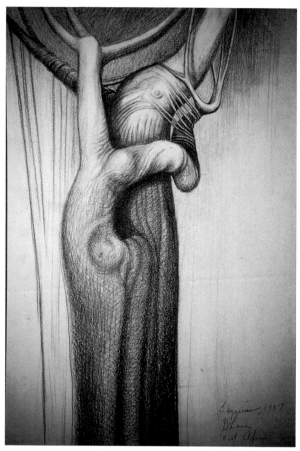

figure 40
Ghana Forest Tree
Conté crayon on paper
1959

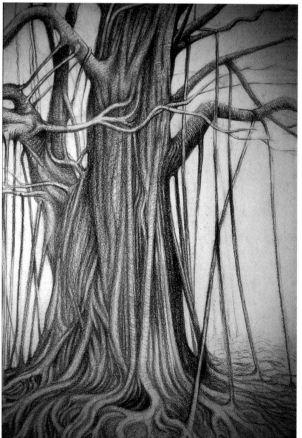

figure 41
Kuma Tree
Conté crayon on paper
1959

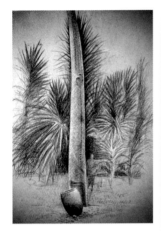

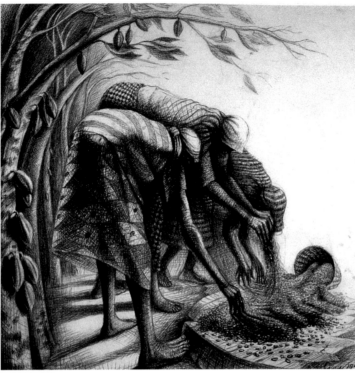

figure 42, left
Obelisk
Conté crayon on paper
1959

figure 43, right
Cocoa Farm
Conté crayon on paper
1959

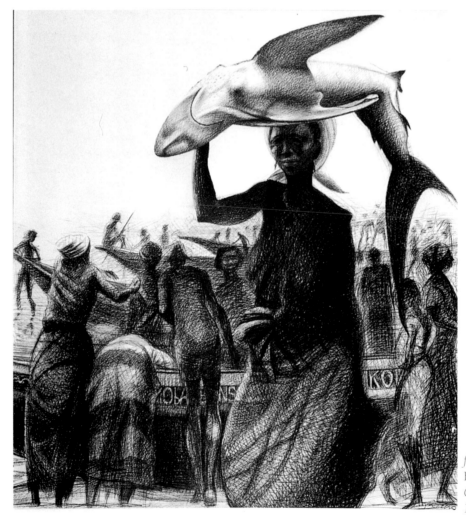

figure 44
Harvest from the Sea
Conté crayon on paper
1959

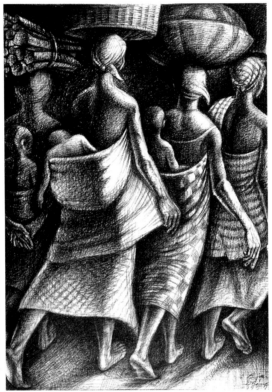

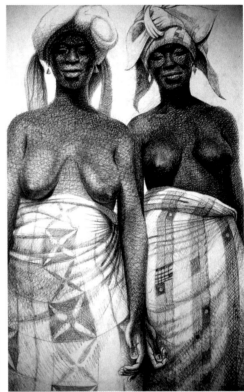

figure 45, left
Women Walking to Market
Conté crayon on paper
1959

figure 46, right
Two Women at Work
Conté crayon on paper
1959

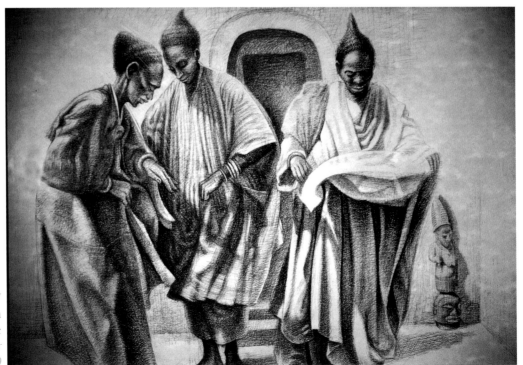

figure 47
Three Priests Before a
Shrine
Conté crayon on paper
1959

Biggers was convinced such an effort would be the work of a lifetime, not of months, but he was expected to produce drawings soon after of his return to the States. He particularly wanted to understand and depict the West African concept of *maame*, a word signifying great respect for women as a leaders and nurturers, the "Great Mothers." Biggers saw parallels between the idea of *maame* and the role that such women as Harriet Tubman, Sojourner Truth, and Mary M. Bethune had played in the movement out of slavery in the United States. He returned to his books about Africa, Ghana, and the Akan people, and eventually found a way to begin work through African folklore. Ananse, the spider, was a central character in many African tales. He was a trickster, problem-solver and organizer. Something in those stories gave John the approach that he needed to write about the journey to Africa and to complete eighty-one drawings for his manuscript, *Ananse: The Web of Life in Africa* (1962, 1967, 1996). The highly successful book was first published in 1962 by the University of Texas Press, and is now in its third printing.

Alvia Wardlaw, in *The Art of John Biggers: A View From The Upper Room* (1995), observed that the publication of Ananse helped replace Hollywood inter-pretations of the "Dark Continent" in American thinking with realistic images of African life. She pointed out that the book became known by word of mouth, a time-honored means by which African Americans learned about and took pride in their heritage. Publication coincided with the beginnings of the civil rights move-ment. Said Wardlaw, "It arrived like a magnificent and unexpected gift. *Ananse* helped elevate the collective black consciousness to a new and higher level of self-awareness."[6]

As Lowenfeld had died in 1960, Biggers was asked if his mentor ever saw the work he'd done for Ananse; he replied with some sadness that Viktor never saw *Ananse*. He'd never had an opportunity to read what John said about him in the book. Biggers sent him a rough draft, but he never saw the finished book. "No.

He never saw that. He was gone … but he knew what I'd done."[7] Biggers again reflected on the Ananse drawings with a far-away look in his eyes:

> You know, I had those eighty something drawings from Ananse
> around here for a long time. They were big and they were everywhere.
> It took thirty years for folks to understand and want them. People
> would laugh and ask me what I was doing that stuff for. Back then, no
> one saw a relationship between American blacks and Africans.[8]

For the several years prior to the trip to Africa, John had worked on drawings for a mural that was to be installed in the new Nabrit Science Hall on the Texas Southern campus. Biggers's aim was to show the interconnectedness of all nature from a matriarchal, African-centered point of view, rather than from the patriarchal approach often favored in European art.[9] The murals of Mexican muralist Diego Rivera were a particular source of inspiration, especially the one in the Chapel at the Universidad Autonoma de Chapingo [10] and the east wall fresco at the Detroit Institute of Arts. Michelangelo's Sistine Chapel and tomb of Guiliano de Medici in the Medici Chapel in Florence provided inspiration as well.

In this mural drawing for *Web of Life* (1962) (fig. 48), rendered precisely in scale, Biggers skillfully used value gradation from light to dark to bring the eye to rest on the dominant form, the African earth mother with child and the

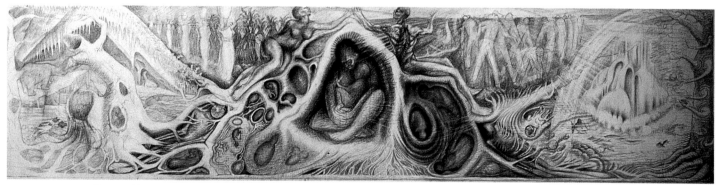

Figure 48
The Web of Life
Pencil drawing for mural
4' scale

developing infant shielded in a protective cocoon, the placenta. Chiaroscuro, a drawing technique popularized by Leonardo da Vinci, enabled an artist to create the illusion of three-dimensional form through the use of contrasts of light and dark.

Upon his return from Africa, Biggers transferred that mural drawing to a large canvas and rendered this small sketch into a full-sized 72-inch by 312-inch mural, tiny brush stroke by tiny brush stroke. Only the addition of a small spider and its web changed the mural from its original small-scale drawing plan. The completed mural, *Web of Life* (1962), was rendered primarily in shades of black, grey-green, and brown, effectively a large-scale drawing on canvas.

The mural was well received in the Houston community. Mimi Crossley, art writer for the *Houston Post* called it "a mural that ranks with national treasures."[11] In retrospect, admirers of Biggers's work came to recognize this mural as a significant turning point in his aesthetic development. In preparation for his major retrospective exhibition mounted by the Museum of Fine Arts, Houston, 1995–1997, *Web of Life* was repaired and restored by a team of restoration specialists. (The mural, on canvas, had suffered serious damage and had been in storage for some years.)

In fact, at the time of its completion, John Biggers's overwhelming passion for all things African had become a source of irritation to many. In 1965, Texas was still a segregated state. Public schools and universities were not desegregated until 1969–1970. Matters pertaining to racial and ethnic differences remained unspoken though deeply felt. Biggers believed that the truth of one's racial heritage should be a matter of pride, not shame and embarrassment. Although this seems obvious a half-century later, this notion was considered radical at the time. As his mentor, Viktor Lowenfeld, had suggested many years earlier, Biggers believed that such acceptance would lead to a more positive and confident African American community.

Biggers organized his teaching curriculum with a heavy emphasis upon African art and heritage. Biggers encouraged his students to paint and draw their own concerns about their racial heritage with pride and honesty. But even within the college family Biggers found resistance to these ideas, even from some of his students. As he spoke with fervor and excitement about the meaning and importance of Africa, hostility seemed to intensify in direct proportion to his enthusiasm.

This frustration, the inability to gain the respect for his ideas from some students and colleagues, led to a habit of weekend drinking that plagued him for many years. At one point, John's mother, living with John and Hazel, spoke sternly to her son: "Son, if you don't stop all that drinkin', Hazel and I are going to have to divorce you."[12]

Nonetheless, Biggers's influence and stature continued to grow throughout Texas. In 1964, John Biggers was named recipient of the prestigious statewide award, the Minnie Stevens Piper Foundation Professor for outstanding scholarly and academic achievement. Biggers required all his senior art majors to paint a mural. Many walls were covered with colorful and dramatic murals. Several patrons of the art department suggested a book to document the work of the students and professors of the Texas Southern Art Department. *Black Art in Houston: The Texas Southern Experience* (1978) was the result. John Biggers and Carroll Simms collaborated with writer John Edward Weems to organize and write the book.

Biggers completed two more murals after *Web of Life* but then quit painting for several years. One mural was a tranquil rural scene complete with horses and animals: *The Red Barn Farm* (1960), rendered in a particularly realistic form for a local veterinary clinic. The other, *Birth from the Sea* (1966), for a branch of the Houston Public Library, owed a good bit to Botticelli's *Birth of Venus* as well as the *Ananse* drawings.

Biggers accepted a visiting professorship of art (1965–1966) at the University of Wisconsin in Madison, Wisconsin. Though he and Hazel enjoyed the year, the

cold weather was difficult for the couple, and that summer, they returned to warm and humid Houston.

Through the success of *Ananse*, Biggers was given many opportunities to illustrate. He did a folio of drawings for Pearl Buck's *The Good Earth* (1966), published by the Reader's Digest Association, which included *The Seed* (fig. 49). Recalling the difficulties he'd had drawing for Buck's book, he remarked, "I'd never been to China and didn't know Chinese peasants, so I finally just drew field workers and put 'coolie' hats on their heads."[13] For Lorenz Graham's *I, Momulu*, Graham Books (1966), he rendered a series of some twenty drawings, inspired by Graham's experiences in Africa. *Illustration #20* is shown (fig. 51). For Marian Anderson's *The Word* (1965) he created this lithograph (fig. 50). (The reader may recall the appearance of these two faces from Biggers's earlier murals.)

Although the storms of the civil rights movement and campus conflicts swirled around him, Biggers focused inward, wrestling with his own internal concerns. He had lost his friend and mentor, Viktor Lowenfeld, in 1960. He was struggling with his own life's work. It was a turbulent time.

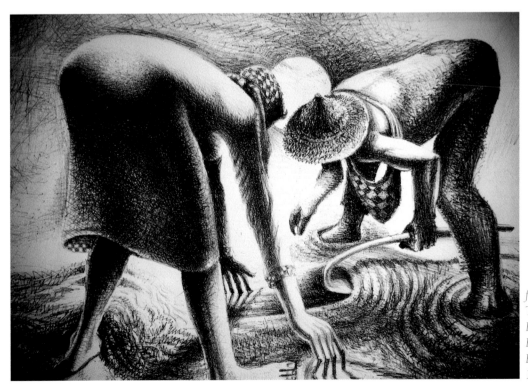

figure 49
The Seed
Lithograph,1983
From illustration for Pearl
Buck's The Good Earth.
1966

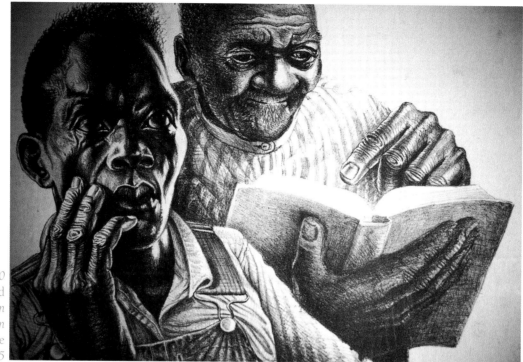

figure 50
The Word
Lithograph, first edition
proof for Marian
Anderson's People
1965

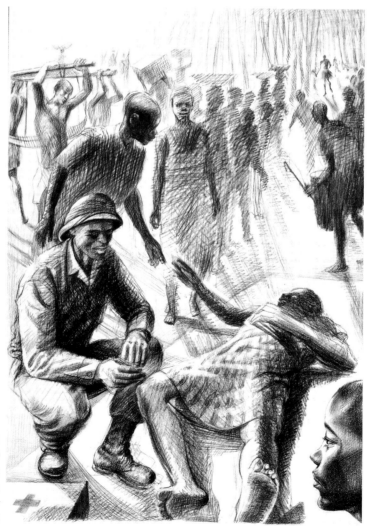

figure 51
Illustration #20
From Lorenz Grahams's
I, Momolu
Conté crayon on paper
1966

Gleaning (mid-1960s) (fig. 52), a glistening litho proof, brought him back to a dominant theme of his early drawings: working the land by harvesting and gleaning. The artist's elderly mother was the model for the drawing. He was inspired as a young student by Jean-Francois Millet's famous painting, *The Gleaners* (1857). This drawing might be contrasted with *Harvesters I* (1947) (fig. 11) to fully appreciate the maturation of Biggers's technical skills.

But across the South, the winds of change had been blowing. A bomb blast destroyed the Sunday morning quiet at the Sixteenth Street Baptist Church in Birmingham, Alabama, on September 15, 1963. Four little girls who were attending Sunday school that traumatic morning were killed in the blast. This destruction occurred barely two weeks after the historic March on Washington, which climaxed with Martin Luther King Jr.'s historic "I Have A Dream" speech. The deaths of Denise McNair, Cynthia Wesley, Carole Robertson, and Addie Mae Collins horrified the nation. Riots exploded in Birmingham, resulting in two more deaths. *Give Me Two Wings* (sometimes listed in the colloquial as "*Gimme Two Wings*") was part of John Biggers's lithographic response to this terrible act that so focused the nation's attention on the significance of civil rights in the United States. Biggers noted that he had completed three drawings in a single weekend in tribute to the civil rights movement: *Give Me Two Wings* (mid-1960s) (fig. 53) *Man of Fire* (mid-1960s), and *Mother and Children* (mid-1960s) (fig. 54). Biggers reflected that some of his students might have expected more activism from him during that time, but that he believed he'd fought his civil rights battles at an earlier time and in another way.[14]

Mother and Children (mid-1960s) exquisitely communicated a longing for the cherishing love of mother and family, the spirit of *maame*. Biggers repeated this image in a variety of ways: pen and ink as well as lithograph and conté crayon. Hazel Biggers still treasures her special gift from John, a delicate and unusual version of *Mother and Children* (mid-1960s) rendered in pen and ink in a stippling technique.

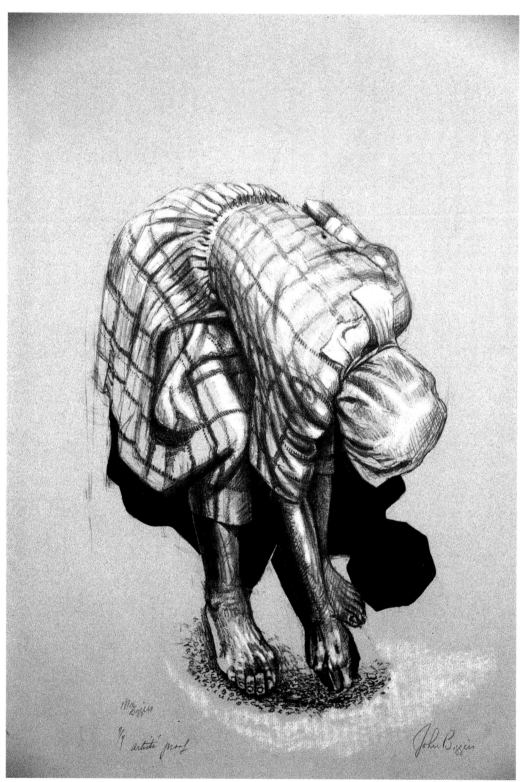

figure 52
Gleaning
Lithographic proof on
paper
1963

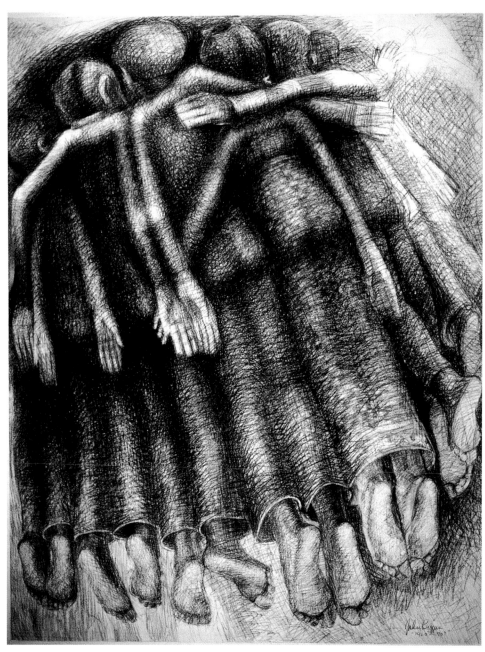

figure 53
Give Me Two Wings
Conté crayon on paper
Mid-1960s

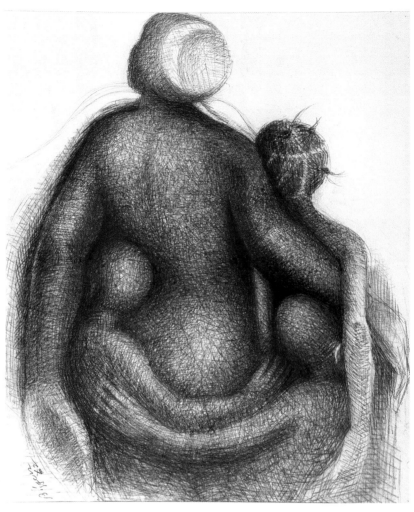

figure 54
Mother and Children
Conté crayon on paper
Mid-1960s

The idea of maame continued to hold Biggers's interest throughout the rest of his life, well represented by his growing African sculpture collection.

Finally, in the fall of 1969, John Biggers returned to Africa. A Danforth Foundation fellowship gave John and Hazel Biggers the opportunity to visit east Africa, including Ethiopia, Sudan, Kenya, and Tanzania. Biggers enjoyed telling the story of how the foundation awards became part of President Lyndon B. Johnson's plan to integrate the colleges and universities in Texas. He said that in 1968, President Johnson was determined to integrate colleges and universities but had little success. So he invited college presidents to a meeting at the Rice Hotel in Houston, and the twelve who came all received foundation grants for their institutions to be awarded to selected faculty members. Each recipient was to be given $10,000 with instructions to spend it on something that had great meaning. Recipients were not

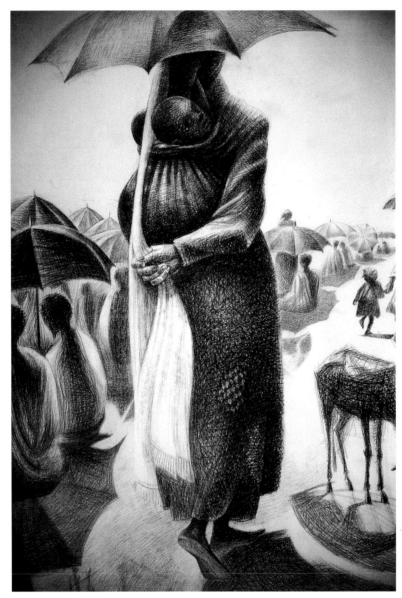

figure 55
East Africa Gondor
Market
Conté crayon on paper
1970

to invest the award but were to use it to expand their interests. That meant that John and Hazel Biggers were then able to go to Africa, traveling comfortably instead of third class. Biggers mentioned that the trip had a lot to do with his developing images of the transformation of the soul, the theme of the Bass Park mural, *East Texas Patchwork* mural, and the Hampton and Winston-Salem murals. [15]

East Africa Gondor Market (fig. 55) came from that 1969 journey to Ethiopia, in which Biggers continued to explore the maame spirit. Biggers continued to work on some of those drawings for twenty or more years. The energetic *Migration* (1957–1988) (fig. 56) is one of those drawings, in which conté crayon, charcoal,

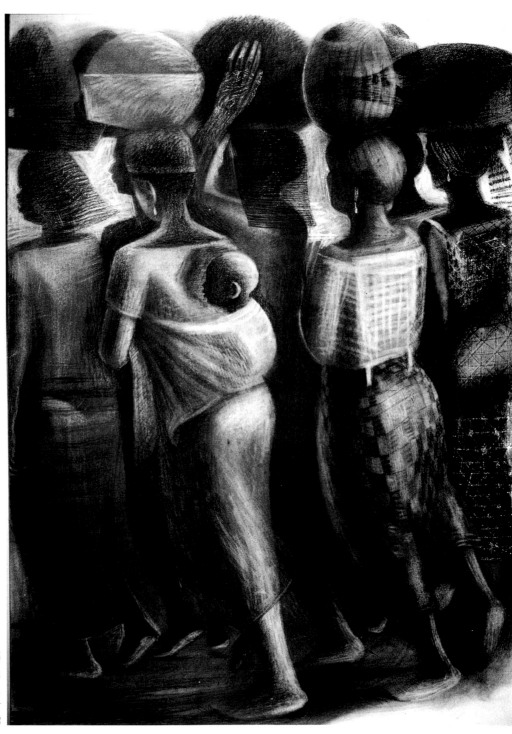

figure 56
Migration
Conté crayon, acrylic,
charcoal on paper
1957-1988

and acrylic have been used. The image of women carrying infants on their backs with household goods balanced on their heads communicated the concept of the universal to John Biggers. That well-chosen title, *Migration*, might well be seen as the precursor of Biggers's transition into the following decade of synthesis and metamorphosis. In the pattern on the women's skirts, we can see the beginning of his development from smooth naturalistic shapes to abstract geometric patterning. John Biggers has flattened space into repeated textile patterns. His search for the most meaningful way to combine these pieces continues in the following chapter.

Developing and Integrating the Iconography: 1974–1983
FITTING THE PIECES TOGETHER

CHAPTER FIVE

John Biggers once said, "I'm not a talker, I'm an artist. I express my ideas through my art. My thoughts just come out. They don't follow any logical order."[1] While Biggers's analysis may have been true, it was a bit of an understatement. John Biggers wrestled with complex ideas and philosophical inquiry throughout his life and he did enjoy talking about and sharing his thoughts.

He was now on a quest to integrate his understanding of African mythology and art with his life as a black Southern male of the mid-twentieth century. Out of that inquiry, he hoped to create a new form for his art that would express an integration of these two worlds. Piece by piece, Biggers began to create a metaphoric language that would speak to the human spirit of matters of importance: birth, life, love, family, hope, transformation, regeneration, and ascension.

But assembling this quilt of ideas did not come easily. Following the 1969 trip to Africa, Biggers became ill. He was unable to think or work creatively for several years after the trip. Guiding his art program took all his energy. In a strange and depressing episode on campus, *Web of Life* (1962) was carelessly damaged

and several of his students' murals were destroyed in the process of remodeling a hallway to create a window to the new computer lab. Fortunately, the murals had been previously photographed for publication. This damage to the murals was devastating to the morale of students and faculty and aroused vigorous student protest. Biggers had to be hospitalized and was diagnosed with tuberculosis of the throat.[2] He stopped smoking and made an effort to control his drinking, but the internal discontent continued. In his intent to find a new form for his art, he remarked that "he felt it was his art that was making him sick."[3]

In 1974, the students at Texas Southern University asked him to paint a sixty-foot mural for the new Student Center. He attended an exhibition at the Museum of Fine Arts, Houston, *African Art of the Dogon*, which began to stir his imagination again. He knew that he had to move away from figuration to successfully integrate African sculptural forms with his ideas. He just did not know how he would do it. Biggers spoke of that struggle:

> *I was bruised like Jacob wrestling with the angels while doing this. Over a period of several years, I tore up drawing after drawing, started over and over again, but nothing was right. Finally, I did some ten-foot drawings and felt that I was learning something. I rushed over, put that drawing up and left it there for a long time. Gradually I worked out the rest of the images… with great difficulty… it was never conceived as a whole, but progressed from drawing to drawing as the images came. Finally I broke away from the* Web of Life *(1962).*[4]

The first drawing for the mural *Family Unity* was *Upper Room* (1974) (fig. 57). Drawn in black and sepia conté crayon, it was rendered in a figurative realism, but with a hint of the geometric abstraction to come. Two women lift up a shack-like structure with their hands and shoulders. Inside the house a table and a bed can be seen and an open window beyond. Children climb a ladder held by a third woman's broad shoulders. Her strong hands support the others. It is a haunting

figure 57
Family Unity
Original drawing, far left
side. Conté crayon on
prepared plaster wall
1974

image graphically describing the many women raising families as single parents, supported only by each other. The truth and universality of that drawing resonated with viewers. Discussing these drawings, Biggers commented that "I wanted to honor those marvelous women, our mothers and grandmothers, who had carried us through life by the sweat of their own physical labor and love." [5]

figure 58
Holy Family
Conté crayon on paper
1974-1978

The second drawing, a preliminary study for the mural *Family Unity* (1974–1978) (fig. 58) brought together the generations for a portrait of family history. Exploring his developing style, Biggers fused old age, conception, infancy, and the family unit into what he named the "holy family." It was a boldly symmetrical pyramid shape that suggested complete stability. By softening the edges decoratively with elements of quilt patterns, he introduced connections to his mother and grandmother, both quilters. He retained some of his usual elements, such as the characteristic large hands and feet, important figures facing inward, and the use of crosshatching to build volume. But this family group represented much more than a genealogical chart. Biggers reduced the family to its simplest, most essential geometric forms. His skillful use of light and dark in space helps the viewer to understand his evocation of past, present, and future time. Biggers described the "holy family" as "the ancestors, our elders, the descendants, our children, along with the original pair."[6]

The next drawing was the real surprise package for those watching the progress of the mural wall. Dynamic, explosive and inventive, *Metamorphosis—Birth and Rebirth* (1974–1978) (fig. 59) was a startling yet poetic form suggesting the power of the life force. Man and woman, united in creative conception, birth a child, and begin the cycle again in regeneration. Alvia Wardlaw observes, "In this drawing, Biggers has redefined his approach to the human form … he adopted an abstract sculptural style that contrasted strongly with the narrative linearity of his earlier work."[7] This drawing was a giant leap in John Biggers's quest for form that would reduce volumetric structure to its barest essentials, as African sculpture does. Linear realism seemed now behind him.

figure 59
Metamorphosis—
Birth and Rebirth
Conté crayon on paper,
sepia and black
84¼" x 42"
1974

Over the next several years, the artist refined his images for each part of the "holy family" unit, examined in the next chapter. The original drawing for the "Couples" series (1974–1978) is shown here (fig. 60). The initial rendering of *The Ancestors* (1974–1978) (fig. 61) is shown painted on the wall. These forms are geometric, sculptural, and self-contained while expressing some of life's most tender moments. A closer look at the two couples reveals a subtle reference to *American Gothic* (1930) by Grant Wood. The older man to the left, in overalls, is holding a pitchfork upright, while the couple on the left sit under a Gothic arched window.

figure 60
Couples
Conté crayon on prepared plaster wall
1974-1978

figure 61
Ancestors
Conté crayon, acrylic on
prepared plaster wall.
far right
1974-1978

Following the completion of *Family Unity* (1978), Biggers was asked to design a new mural, *Quilting Party* (1981), (sometimes referred to as *Celebration*) to commemorate the opening of the new Music Hall in downtown Houston. Mrs. Susan McAshan, a longtime supporter of the Texas Southern University art department, commissioned the work in 1980. In this developing work (fig. 62), Biggers explored three new areas for his metaphoric imagery: (1) integration of actual African sculptural forms into the work (fig. 63, 64), (2) inclusion of scenes and stories recalled from his African visits (fig. 65), and (3) adaptation of quilt patterns as a textural and structural unifying device (fig. 66). These careful little pencil drawings just begin to reveal the tantalizing mythology of the inventive storyteller.

figure 62, left
Quilting Party/Celebration
Preliminary sketch
Graphite pencil on paper
1980-1981

figure 63, right
Mother with Three
Children
Preliminary sketch
Graphite pencil on paper
1980-1981

figure 64
Mother with Three Children
Wood, African sculpture
Photograph
From the John Biggers
collection

During his trips to Africa, Biggers began to collect fine examples of African sculpture for study and inspiration. Figure 64 is a photograph of a favorite sculpture, which he called both *Dog Star* and *Mother with Three Children*. Figure 62 is a drawing of that piece incorporated into the star section in the new mural. Figure 65 captured the celebratory dances that he witnessed in Ghana. Earlier he created a prizewinning painting, *Jubilee: Ghana Harvest Festival* (1959–63) that sparkled with that same exuberant excitement. With the *Quilting Party* (1981), Biggers introduced the African xylophone, the balaphon, as a feature symbolizing music. This instrument gained significance as Biggers's work developed.

figure 65
Dancing Women
Graphite pencil on paper
Preliminary drawing,
Quilting Party/
Celebration
1980-1981

figure 66
John Biggers at
Quilting Party *wall*
Dancing Women
Acrylic on canvas
1980-1981

Discussing his frequent use of quilts in so many paintings and murals, Biggers commented that quilts had been a symbol since his earliest works, but that for a long time it was almost unconscious. Now, he agreed, the quilt had become the structure for his murals and integral to his paintings. His voice husky with emotion, Biggers spoke of the symbolism of the quilt design: "Putting together those pieces of materials that have been discarded, worn … it's like putting life together again … building something together. It's a marvelous symbol of order, creativity." [8]

As his new ideas began to emerge, Biggers's restlessness within the academic community intensified. The time demands of teaching and administration conflicted with time for his work and he longed to spend full days in his studio. By 1980, he had completely given up alcohol, the consequence of being involved in an auto accident.[9] Fresh ideas were flowing with the tantalizing possibility of retiring soon from teaching.

figure 67
John Biggers with
Christia Adair
Photograph
1982-1983

figure 68
Shotgun motif
Acrylic on prepared
plaster wall
1982-1983

Biggers had been commissioned by the Harris County Board of Commissioners to create a mural honoring Christia V. Adair, an important civil rights activist in the county. He accepted the commission, but soon found himself trapped between his familiar ways of working and his newly developing style. Ms. Adair wanted her image to "look right" and Biggers wanted to focus on his new abstractions, a real conflict between *visual* and *haptic* approaches to form. He did many sensitive studies of Ms. Adair, her home and family, making every effort to please her, but she thought he was making her "look ugly" (fig. 67).

Though Ms. Adair was interested in likenesses, John Biggers was creating a new approach to space, making a repeat pattern of the shotgun roofs, like city row houses or a rural row of sharecroppers' shacks. Called a shotgun house, such a house would be long and narrow, with a porch in front and a window at back, a table, a bed, and little else. The openness from front to back assured some ventilation in the hot, humid weather of the South. John had carried this image in his mind since his Hampton days. Glancing at a family quilt on the studio wall, he noticed that the triangular patterns looked like rows of sharecropper shacks, and thus his "shotgun series" was born (fig. 68). He often remarked that he was trying to keep the idea of individual shelter while responding to the architectural feature of the flat wall. This motif was to form the basis for one of his most successful series of paintings and lithographs.

On May 31, 1983, Biggers retired from Texas Southern University and the art department he had built and loved. Soon after, the *Christia V. Adair* (1983) mural was dedicated in a specially constructed pavilion in the sunlit Christia V. Adair Park in Harris County. But he did not retire to a slower pace. Quite the contrary, John Biggers's career began to accelerate in intensity. As greater recognition occurred in the wider community, exciting new projects appeared. The last eighteen years of John Biggers's life were to become his most productive.

John Biggers had undergone a process of self-renewal similar to the artists of the early twentieth century who had sought to free themselves from the artistic conventions of nineteenth century Realism/Naturalism of the preceding century. Colin Rhodes in *Primitivism and Modern Art* (1994) suggests that the early Modernists too looked towards primitive art, particularly African, folk, and child art as sources for innovative conceptions. We recall that John Biggers had received the foundation of his art education (1941–1954) under the tutelage of the highly educated Viennese refugee, Viktor Lowenfeld, who was well acquainted with the Modern movement in twentieth-century art.

However, until the completion of the mural *Family Unity* (1974–1978), there appeared little direct Modern influence in Biggers's work. We might now ask if John Biggers's newer works are essentially of the Modern Period, rather than of Social Realism or Expressionism. Kirk Varnedoe, in *A Fine Disregard: What Makes Modern Art Modern* (1990) suggested that one might identify four main characteristics of Modern art:

1. *Flattened images instead of the illusion of space.*
2. *Fragmentation and repetition in the composition rather than the complete object.*
3. *Primitivism in the sense of revealing something new about ourselves.*
4. *The flight of the mind, the freedom to assume any point of departure, or to conceptualize as one wishes.*[10]

Looking back through this transitional chapter, one can identify these characteristics as they develop. In the flattening of the shotgun roof tops into a repeated pattern in the *Christia Adair* (1983) drawings; the flights of the imagination when the known world is rearranged, flattened into geometric shapes, and floated in improbable spatial positions in the *Celebration/Quilting Party* (1981) drawings; the incorporation of African sculpture and home and farm and objects turned into objects of reverence in *Family Unity* (1974–1978). It appears that John Biggers had become a Modernist.

Mature Years 1984–2001

QUILTING: FINISHING THE QUILT

CHAPTER SIX

In the following decades, the bold designs of John Biggers's quilt grew full and rich. Biggers received more of the wider recognition that had eluded him for most of his career. Freed from the responsibility of the academic world, Biggers was able to work in his studio, travel, research his expanding ideas, and evolve new works. In an interview with Thad Martin for *Ebony* magazine in 1984 he said, "Now I want to paint murals and draw… I want to be an artist. I'm in love with art, with the spiritual aspirations of people, of African Americans. My job now is to reach the universal through the black art experience."[1] It was a tall order indeed.

Following his official retirement, Biggers accepted commissions for two more murals. The first was *Song of the Drinking Gourds* (1987) in Houston's Tom Bass Park. That gave Biggers an opportunity to give form to his idea of the transformation and ascension of the human spirit. The second, *East Texas Patchwork* (1987), was commissioned by the Arts Council for the Public Library in Paris, Texas. In this mural, Biggers expanded his theme of cleansing and transformation. The working drawing (fig. 69) shows Biggers's meticulous planning for value, pattern, and color. A significant feature of this mural was the interweaving of the

cleansing ritual with the interlocking shotgun motif. The figures, facing inwards, were simplified to geometric shapes. For those in the local community who were not aware of Biggers's transition from figurative form to geometric abstraction, the piece caused some controversy, which soon settled.

In a neighboring county in northeast Texas, a flurry of excitement erupted when an early mural of Biggers's, presumed destroyed, was found in some disrepair, in a public school storeroom near Daingerfield, Texas (Chapter 3, fig. 34). John Biggers had visited local Houston schools decades earlier, recruiting teachers for an art education class at the new college. In parallel circumstances, while looking for a projector to use, I came across that missing work, stored forlornly behind the overhead projectors and map carts. Biggers's distinctive style of using a paintbrush like a drawing pencil, in tiny hatching and crosshatching strokes, made it immediately recognizable. An opportunity to meet John and Hazel Biggers soon followed. The mural had been originally installed in March 1955, commissioned to celebrate the opening of Carver High School, the first high school for Negroes in Morris County, and to honor the well-loved founder and principal, Mr. P. Y. Gray.[2] On October 27, 1989, the community rededicated and re-installed the newly framed mural, *The History of Negro Education in Morris County* (1955), with John Biggers as the honored speaker. Before the rededication ceremony, Biggers noticed some damaged areas on the mural and offered to repaint what he could. Paint and brushes were hastily supplied, and the artist stepped over the protective rail and restored his "lost child."

Biggers's enjoyment of the lithographic process brought him to the further development of powerful images derived from his mural, *Family Unity* (1974–1978). He began the lithograph *Upper Room* (1974) as he was working on the mural. In the fall of 1983, he completed this four-color edition in deep blues (fig. 70). The title recalled an African American spiritual of the same title, which spoke of the spiritual peace of waiting in prayer. Though he had once described himself as

figure 69
East Texas
Patchwork
*Preparatory
drawing*
1987

"irreligious," he often referred to biblical events and places, using African American spirituals as the titles for his works. The years of reading the Bible as a child with his family and listening to and singing Gospel hymns had become an integral part of his being, even as he discovered African mythologies and beliefs.

During these decades, Biggers drew from the rich depository of images that his earlier murals and drawings provided. Epitomizing the haptic artist, the person who works from feelings first, he commented, "In my work, I reach back and grab things again. As you're conceiving, you never explore everything you feel. There are other things that can come out of it.

figure 70
Upper Room
Lithograph, 4 color
1984

You're thinking that you're going to get a complete new thing but how many images are going to be coming out of your own heart?"[3] John Biggers has been so prolific, and so many works of his were sold or occasionally given throughout his creative years that it would be difficult to even estimate a number.

Upper Room (1983) developed imagery that began to have great symbolic meaning for him. Throughout his career, he had emphasized the importance of the contribution women have made to the survival of his people. The sight of women lifting home, education, and children on their shoulders was an unforgettable image. The matriarchal notion of *maame* was framed in the context of the African American family roots.

The simple narrow shotgun likely had its roots in Africa. It was a common structure throughout segregated black communities in the South. The title, *Upper Room* (1983), suggested a sacred place in which life is conceived and lived. The school bell on the roof implied that the house was both a place of learning and nurture. Children, linked to the ascending ladder, climb higher than their elders who are doing the heavy lifting.

But why those wash pots, the bottle tree, the turtles, and the scratching chickens transformed into birds in flight? Biggers often spoke of the essentials of his childhood in his home: great iron pots that were used for washing clothes, rendering lard and making soap, the tree hung with bottles to scare away the predatory birds, the turtles in the nearby creek, and the chickens scratching in the yard. These familiar objects took on increasingly symbolic meanings in Biggers's work.

A subtle change is also evident in his depiction of space. Various spatial devices are utilized, such as placement and overlapping while some of the shapes seem to be flattened into a more shallow space. Pressed to discuss the meaning of *Upper Room* (1983 and 1990), Biggers responded that he was speaking of values within the family. The three figures represent the forerunners, those who led the way. He continued: "Inside is the table (and I think of the idea of the Last Supper),

that meal of communion with the family. Beyond the table is the bedroom … the birthing place, that's where life begins. And out of the window, the light comes through. Did you notice the cross in the light?"[4]

With the *Four Seasons* (1983) lithograph (fig. 71) Biggers returned to the *Christia Adair* (1983) shotgun motif in which women, each holding a small shotgun cottage as a sacred reliquary, stand in front of porch doorways. The shift from spatial depth to the flattened shallow space was more noticeable in this lithograph. A pattern of triangular rooftops was laid out like a quilt composed of small triangles. There is no linear perspective, no sky, just roof stacked upon rooftop. Each woman is unique in appearance, yet each stands expectantly on her porch.

This composition is reminiscent of figures set in a medieval Gothic altarpiece or the porch maidens of the *Erectheum* of ancient Greece. Studying *Four Seasons* (1983) Biggers drew a parallel between the simplicity of African art and medieval art: "The older I got, the more I loved the simplicity of African art because the form was there. But when it came to subject matter, it wasn't the Renaissance artists that I studied. It was the Gothic artists. Such simplicity."[5]

figure 71
Four Seasons
Lithograph, 4 color
1984

On the porches are large wash pots and scrub boards, those echoes of Biggers's childhood. There is a light in front of the first house. This community of waiting women stands on the other side of the railroad tracks. And only the turtles climb over tracks and steps. The birds ascend to the rooftops, a faint reference to the maturing theme of transformation and ascension. Robert Ferris Thompson compares the iconic significance of the *Shotgun* series to Grant Wood's *American Gothic* (1930), citing one as a "perfect pendant" to the other.[6]

Some viewers ask about *Four Seasons* (1983) and its meaning. Biggers responded that each woman on her porch represents the head of a household. Women, he seemed to say, light the way for their families, provide and care for them and are the stable center in the life of the family. The women were depicted out of proportion to the size of the doorways, because to each family, those women are larger than life. [7] Clothed in ordinary housedresses, but wrapped in African head cloths and Egyptian headdresses, his depiction of these women inferred the interweaving of African and Southern sharecropper heritage.

The *Shotgun* series of lithographs and paintings became an icon for community revitalization in Houston's Third Ward with Project Row Houses. In the early 1990s, community activist Rick Lowe saw Biggers's iconic images as a powerful symbol of African American community life. He applied for and eventually received a $25,000 grant from the National Endowment for the Arts to begin renovation of the abandoned shotgun houses on two adjoining blocks. Today that renovated area supports thriving arts events and activities. [8]

Biggers developed a series of lithographs based on his dynamic evolution of form in *Metamorphosis—Birth and Rebirth* (1974–1978) (Chapter 5, fig. 59), originally a detail sketch for *Family Unity* (1974–1978). He referred to these lithographs and drawings as his "Couples" series, also derived from the mural. He experimented with this theme over a ten-year period from 1975 to 1985, coming back again and again to different versions. *Wedding* (1974) was similar to the fluid abstract central

drawing from the mural. Biggers once explained that in order to enter shows while he was so involved in the mural, he would select individual sections to render as drawings or lithographs.[9]

Clearly enjoying the sensual possibilities in his sculptural abstractions, Biggers drew the *Wedding Dance* (1975) (fig. 72) and *Nesting* (1983) (fig. 73) in which he suggested the idea of pregnancy. *Red Family* (1974) (fig. 74) and *Family with Pots* (1975) (fig. 75) depicted the fulfillment of the Couples series with the birth of a child. In *Red Family* (1974), he returned to figuration, but in the later version, the child figure has evolved into a more abstract geometric form, as in his later family series. We get the sense of a quilter stitching pieces together, then ripping out a block and replacing it with a different color or texture.

figure 72
Wedding Dance, SeeSaw
Conté crayon on paper
1974

figure 73
Nesting
Conté crayon on paper
1983

figure 74
Red Family
Conté crayon on paper
1974

figure 75
Family with Chair and Pots
Conté crayon on paper
Mid-1970s

figure 76
Midnight Hour
Conté crayon on paper
39" x 29 ¼"
1985

In 1985, John Biggers completed the last lithograph in this series, *Midnight Hour* (fig. 76). By far the most complex and highly abstract of these works, this bold exciting piece deals with the moment of conception. Of this complete series, *Midnight Hour* (1985) alone contains the excitement and energy of the original drawing, *Metamorphosis—Birth and Rebirth* (1974) With the extraordinary futuristic design of *Midnight Hour* (1985), Biggers extended his range far beyond *Ananse* (1962) and the *Web of Life* (1962).

The artist was especially close to his grandmother as well as to his father and mother. His maternal grandmother had been a part of the daily life of the Biggers family. In the early 1960s, John and Hazel brought his mother, Cora Biggers, to live with them until 1975 when she died. Biggers's research into African culture also led him to see the deep spiritual value in the veneration of ancestors. It was not surprising that he would attempt to depict the elderly as integral to the family. The initial drawing had its roots in the mural *Family Unity* (1974–1978). Ancestors were identified by the rub-board on the back of the female and the bib overalls worn by the male. In the lithograph, *Autumn Twins* (1975) (fig. 77), the elderly couple was seated on a swing, and the woman has placed her arm protectively around the frail male figure. On the grandmother, the shawl was replaced by a rub-board, but the elder man was still clad in bib overalls, clinging to a walking stick.

Biggers continued to expand the family theme with a series of lithographs and drawings. Three versions of the family series are shown here. *Holy Family (a)* (1984) (fig. 78) was composed of parents, grandparents, and child. A new figure appeared in *Holy Family (b)* (1984) (fig. 79) and in *House My Father Built* (1983) (fig. 80). The new figure faces the viewer in an embrace of the family. That figure has been variously interpreted as a personification of the creative force, the Almighty breathing life into humankind, the male ancestor or a human father figure. The star-shaped web extending from the mouth of the new figure wraps around the immediate family, likely in some reference to the spider Ananse and its web from

Biggers's mural, *Web of Life* (1962). Alvia Wardlaw suggested that the origin of the thread from the mouth was Dogon, symbolizing "the transfer of knowledge across generations and continents through the spoken word, in folk tales, proverbs and divine teachings."[10] Other viewers suggested that the threads represented the umbilical cord.

House My Father Built (1983) (fig. 80) is another conté crayon drawing, later a lithograph, that is also open to a wide variety of interpretations. Biggers referred to it as "about woman as twins, the dual nature of woman."[11] In an interview for the Getty Foundation web site, he was asked if it was important that viewers understood the meanings of his symbols. He replied, "It is important to me that they find meaning in the symbols. It does not matter if they do not see the symbols as I do. Every word we speak … has a different meaning for each of us … same with symbols."[12] These drawings, rendered in color, *Holy Child* (1986) (fig. 81) and *Star Gazers* (1986) (fig. 82), suggest a family parents and children. Figures have been simplified to nearly pure geometric forms, recalling African sculptural objects.

In his studio, John Biggers surrounded himself with favorite drawings or drawings that he considered unfinished. After a period of time, he would take a drawing down and work on it a while and then hang it again. Some of those drawings hung for twenty years or more on a wall, or lay in a drawer or in some cubbyhole. Another such drawing is *Three Women* (1952) (fig. 83), begun in the early 1950s and completed sometime in the 1970s. Three women are seated on straight-backed chairs, with a quilt laid across their laps. This could have be a scene from any group of quilters. Women, at ease with each other, rest and talk after the work is done. Biggers spoke many times of watching his mother and grandmother quilting together.

The Quilters (1952), a similar version of three women quilting, evolved into a luminous painting that Biggers called *Starry Crown* (1987). In that painting, the star-shaped mouth-to-hand thread motif was repeated. *Starry Crown* (1987), received the Dallas Museum of Art Purchase Prize and was featured in the path-breaking exhibition, *Black Art, Ancestral Legacy* (1989–1990). This exhibition, organized by the Dallas Museum of Art, traveled to the High Museum of Art in Atlanta, Georgia, the Milwaukee Art Museum, in Milwaukee, Wisconsin, and the Virginia Museum of Fine Arts in Richmond, Virginia. As a result of this traveling exhibition, John Biggers began to receive wider exposure. Though he was highly respected in Texas art circles, and certainly in Houston, there still had been little national awareness of his abilities or stature.

The lack of recognition did not seem to bother him or deter him from his chosen course. Biggers remarked that Viktor Lowenfeld had advised him not to get involved in all of the "isms" in the current art world. Some of his contemporaries were highly critical of his work, suggesting that he was too narrowly focused, trapped in a tunnel, and would never go forward. He smiled and remarked that "some of those same people, forty years later, have said to me, 'I wish I'd stayed on track.' I followed my own path, set by *Crossing the Bridge* (1942), the *Dying Soldier* (1942), and the *Community Preacher* (1943). The stream, the hill, the railroad track were there at the beginning of my work."[13]

figure 77
Autumn Twins
Conté crayon on paper
26" x 31"
1975

figure 79
Holy Family (*a*)
Conté crayon on paper
1984

figure 78
Holy Family, (*b*)
Lithograph, 2 color
1984

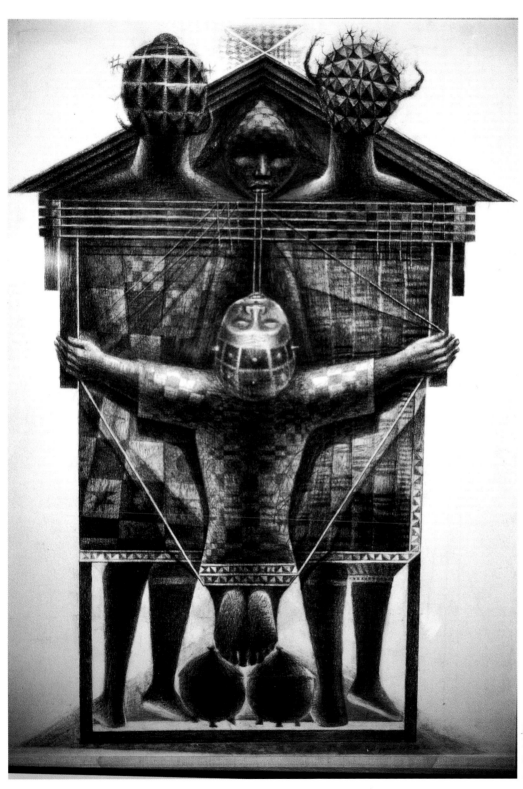

figure 80
House My Father Built
Conté crayon on paper
1983

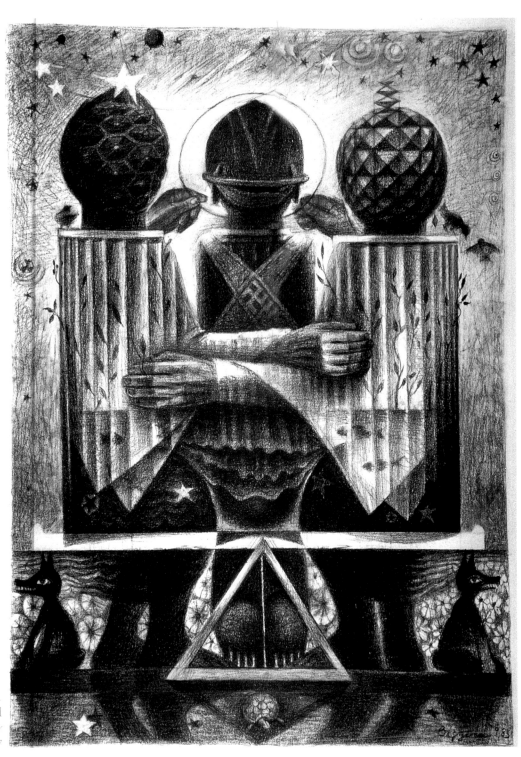

figure 81
Holy Child
Conté crayon on paper
1985-1987

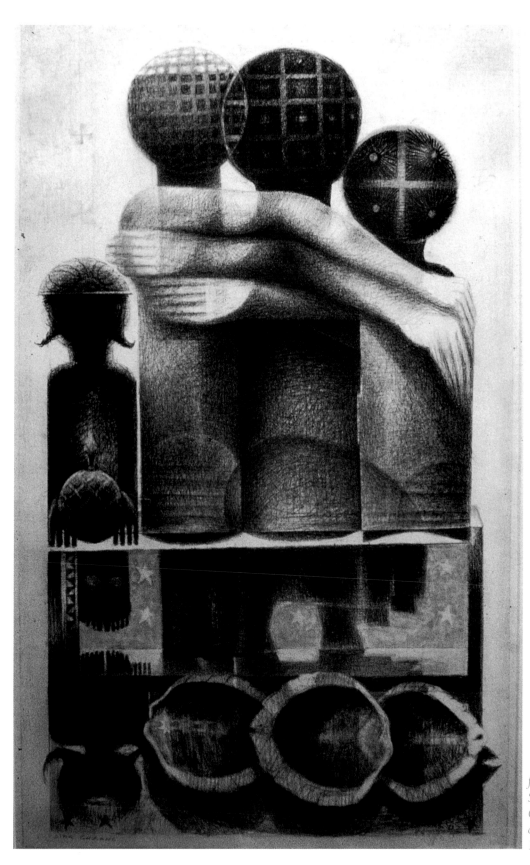

figure 82
Star Gazers
Conté crayon, color,
on paper
1985–1987

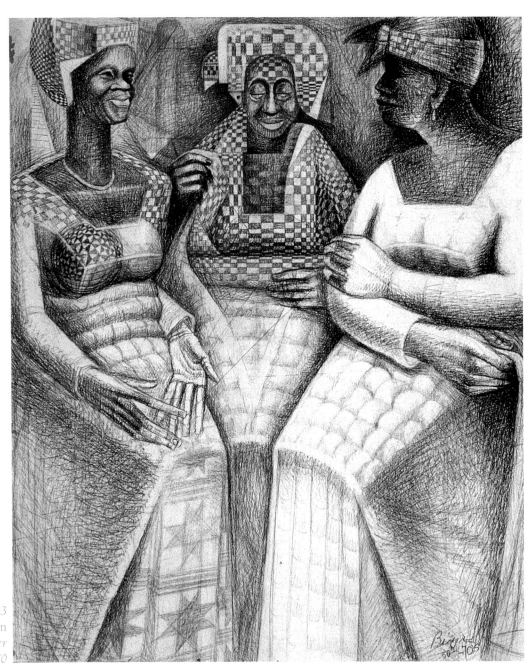

figure 83
Three Women
Conté crayon on paper
1952-1970

During the 1990s, John Biggers was asked to hang solo exhibitions in California, North Carolina, Arizona, Virginia, Arkansas, Oklahoma, and other states. In 1993, the Fayetteville Museum of Art in Fayetteville, North Carolina, asked a well-known art critic of the region to write the essay for their exhibition catalog, *John Biggers: Drawings and Paintings.* Tom Patterson wrote of his first experience with Biggers's work at that show: "In the exhilarating rush of impressions, feeling and thoughts that flooded my mind the first time I encountered a group of John Biggers's sumptuous paintings and drawings, there loomed a big question: Why have I never heard of this extraordinary artist?"[14] Patterson suggested that the reason lay very clearly in the fact that Biggers was an African American with a positive message, working during the era of the white dominated art establishment.

Patterson described Biggers as a Southern artist with awesome talent and a formidable command of technique who had been consistently prolific and aesthetically ambitious, with an important social, cultural, and spiritual message. He concluded that "in the singularly resonant way, John Biggers is the nearest thing I've seen to the quintessential African American visual artist." [15]

Northeast Texas Community College in Mt. Pleasant, Texas, with some support from the Texas Commission on the Arts, presented a selected retrospective, *John Biggers: A Cultural Legacy* (February 1993) in the new Whatley Performing Arts Center on the Northeast campus. The college was located sixteen miles from the newly framed and rededicated 1955 mural. The exhibition was made possible by the generous loan of Biggers's work by Dr. Biggers and several Houston and San Antonio collectors. The interest in his drawings and lithographs in that exhibition suggested a need for this book.

Hampton University and Winston-Salem State University each asked the artist to paint murals for their new buildings. He was excited about the possibilities and accepted both offers. As a result, from 1990 to 1992, Biggers shuttled between these two challenging assignments, 400 miles apart. He asked his nephew, Jim

Biggers, also an artist, to work with him. Both *House of the Turtle* and *Tree House* (fig. 84) at Hampton University were twenty feet in height and ten feet wide. They had to be drawn in sections sideways because there was no room high enough to accommodate the full canvas height. Michelangelo (1475–1564), while painting the ceiling of the Sistine Chapel, wrote of physical pain that came from the overhead position in which he had to paint. Biggers, too, experienced physical discomfort while painting. Because of the room limitations, sometimes he had to work sideways (fig. 84) while lying on the floor.

Despite these difficulties, the murals were enthusiastically received and were the dominant feature of the new library and research center. While continuing to develop his symbolic imagery, Biggers focused on the rich and unique cultural heritage of his beloved Hampton University. The university produced a documentary video recording the progress of these two murals in *Stories of Illumination and Growth: John Biggers's Hampton Murals* (1992).

Origins (1990–1992) and *Ascension* (1990–1992) (fig. 85), at Winston Salem State University, in Winston-Salem, North Carolina, were quite different from the Hampton pair. They were thirty feet high by twenty feet in width. Adequate scaffolding made drawing and painting these murals more comfortable for the sixty-five-year-old painter. More than others of his murals, there was a deep layering of transparent sheets of color, like the sheets of sounds in the blues and jazz. Biggers incorporated the shotguns, the elders, the quilt patterns, and the railroad tracks and added a new form, the ceremonial African comb, to symbolize the soul. From his African journeys, Biggers had collected a variety of these combs and decided that those ceremonial combs would represent the soul's transformation and ascension. He had also worked in reference to the mythic figures Isis and Nephthys.

figure 84
Tree House
Acrylic on prepared canvas
Hampton University mural
10' x 20'
1990–1992

figure 85
Ascension
Acrylic on prepared canvas
Winston-Salem State University
mural
20' x 30'
1990–1992

Discussing these evolving images of transformation and the ascension of the soul, Biggers reflected on their trips to east Africa in 1969 and again in 1987. "Those trips had a lot to do with my thinking. We visited Israel, east Africa, Ethiopia, the Coptic churches, the Jewish synagogues, the Nile River and Mt. Kilimanjaro. Kings were buried on the mountaintop where the snow and ice remained. A transformation takes on top of the mountain when the sun awakes the hibernating animals, and then the cold takes them back to ice again."[16] With the completion of these four murals, he had worked out a narrative that reached back into African and Egyptian mythology.

The effort required to complete the four murals was tiring, but Biggers's creative energies still flowed. He developed a new series of drawings and lithographs at the Brandywine Graphic Workshop in Philadelphia that incorporated his most recent ideas. *Family Ark* (1992) initially was a pencil drawing (fig. 86) that he evolved into an edition in two colors and finally into a four-color lithograph (fig. 87). He drew the piece with litho crayon on three stones, and pulled prints, both as a diptych (fig. 88) and as the triptych shown above. Eight figures, representing parents, children, and ancestors, nestle in an encompassing sphere that is resting on the balaphon. Biggers explained that he selected the balaphon, the African xylophone, to signify a bridge because it was constructed like the bridge at home that appeared in his first painting, *Crossing the Bridge* (1942).[17] The balaphon floated on a watery base. The spaces were filled with objects common to a sharecropper's shotgun house. African artifacts surrounded the family members, whose arms were outstretched. The images Biggers drew from became a language of metaphoric images that may need translation for the novice viewer. For the past two decades, Biggers variously used the big metal wash pot and rub-board as symbols for his mother, Cora, because of those very early associations with her work. Biggers's father Paul farmed and cobbled, as well as taught and preached, so the anvil and a tiller were symbolic of his father.

figure 86
Family Ark
graphite pencil on paper
1992

figure 87
Family Ark
Triptych
4-color lithograph
1992

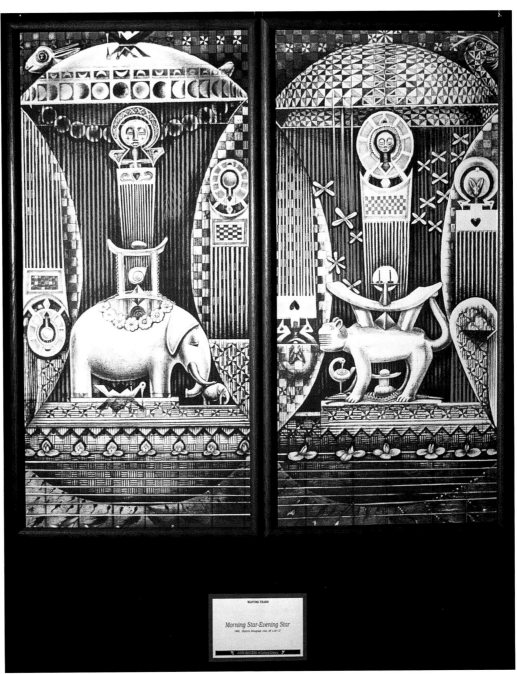

figure 88
Morning Star,
Evening Star
Four-color lithograph
Diptych
1992

The complex African combs remain an all-encompassing metaphor for the human soul. The two side panels contain a wide variety of African artifacts selected from the artist's collection. The stools and umbrellas suggest royal kinship and the animals signify various families and groups. The whole ark floats on water that is teeming with life. Water, for Biggers, symbolized cleansing, rebirth, and regeneration.

figure 89
Metamorphosis II
3-color lithograph
1992
(from earlier drawing,
Creation, 1964)

Biggers mentioned that when he was a young man, he believed that people used the emotional release of the baptismal ceremony of washing in the waters as an escape from facing problems rather than confronting them. He felt that the emotional catharsis that occurred in baptism prevented people from dealing with reality. "That's how I saw religion as a young man. Later, in my own work, baptism became a symbol of renewal. An important part of my work is the cleansing, life giving properties of water."[18]

A second lithograph from the 1992 Brandywine workshop presented a lyrical contrast to the Family Ark series. *Metamorphosis II* (1992) (fig. 89) carries an obvious kinship to several earlier drawings, *Creation* (mid-1960s), *Mother and Children* (mid-1960s), and *Metamorphosis—Birth and Rebirth* (1974). The lithograph is sensuously curvilinear, suggesting mother and children in a field of flowers. This lithograph reads as a love poem, not a manifesto.

Author Maya Angelou was invited to read a poem at the inauguration of President William J. Clinton in January 1993. Soon after that John Biggers was asked to create a special edition folio of lithographs to accompany Angelou's poem, *The Grandmothers* (1993). That commission offered an opportunity for Biggers to give form and synthesis to his desire to honor the grandmother, as the Great Mother, the spirit of *maame*. Said Biggers: "The enduring permanence of the Grandmother is a metaphor for immortality"[19].

Rape of the Earth (1994) (fig. 90) was a working drawing for the folio series. A large woman stands with arms outstretched, her feet akimbo. She arises from a bed of crushed grasses and sugar cane leaves. The woman holds a balathon with gourds attached as resonators. On the balathon rests a broken shell, which Biggers explained represented the violated womb. In conversation with the author, Biggers explained: "Without getting into the physical description of rape, I'm trying to say that man's destructive energy in rape is like nature's force in a hurricane. It destroys the earth into desolate barrenness … yet the woman does endure."[20]

The next working drawing was *Rebirth* (1994) (fig. 91) Biggers turned the Great Mother so she was facing inward, revealing her legs and the infant on her hips. She is rising from the water, holding her body as if in flight. We are reminded of the mystery of birth, new life, and creation. To Biggers, the twins represent new beginnings, rebirth. Out of devastation, life begins anew.

Lift Us Up (1994) (fig. 92) leads even more deeply into Biggers's metaphoric symbolism. This drawing synthesizes the diverse images from three of his earlier symbols: from the *Upper Room* (1983), the load-bearing woman; from *Four Seasons* (1983), the shotgun houses and washtubs; from *Quilting Party* (1981) the family unit and the ancestors. Interpreting this complex image called for a conversation with Biggers. He responded by patiently explaining that the rub-boards indicated the cleansing of the future. The shotgun houses symbolized the womb, leading to rebirth and regeneration. The ancestors stand for the endurance of the past. "What lifts us up? One woman's indomitable spirit." [21]

Morning Star, Evening Star (1994) (fig. 93) is the fourth working drawing of the series. The planet Venus is often called the Morning Star, and at certain times of the year, it appears at night as the Evening Star. It has been associated with the perpetual movement of light into darkness. Biggers again associated the Grandmother with permanence and transcendence. He suggests that the Grandmother has the constancy of the planets orbiting around the sun. In attempting to reach the nub of Angelou's poetry, Biggers used the cyclic nature of the natural world as a metaphor for the individual human life. Life forms rise out of the watery darkness into the brilliance of the starry sky.[22] In some mythologies, the sky itself is a maternal entity, with the sun representing daily rebirth.

The final lithograph of the series, *Return to the Source* (1994) (fig. 94), returned to the mysterious elephant from *Family Ark* (1992). This oval creature stands on a barge-like bird form. An African king's stool rests on the elephant's curved back.

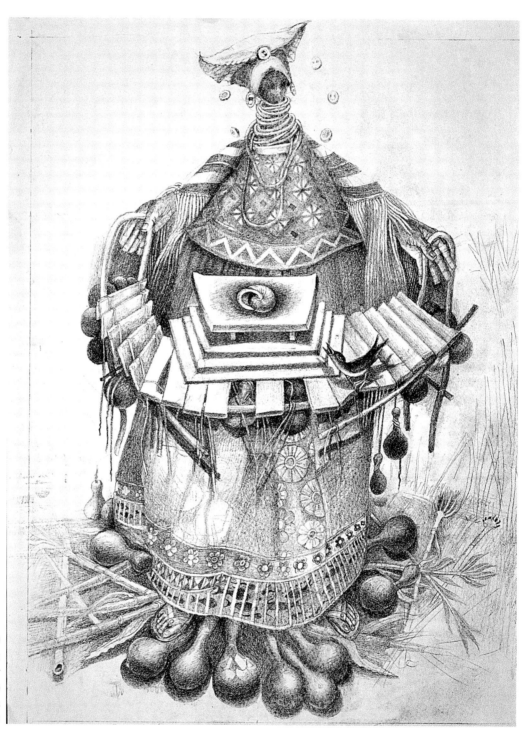

figure 90
Rape of the Earth
Preparatory drawing for
Lithograph folio
The Grandmothers
1994

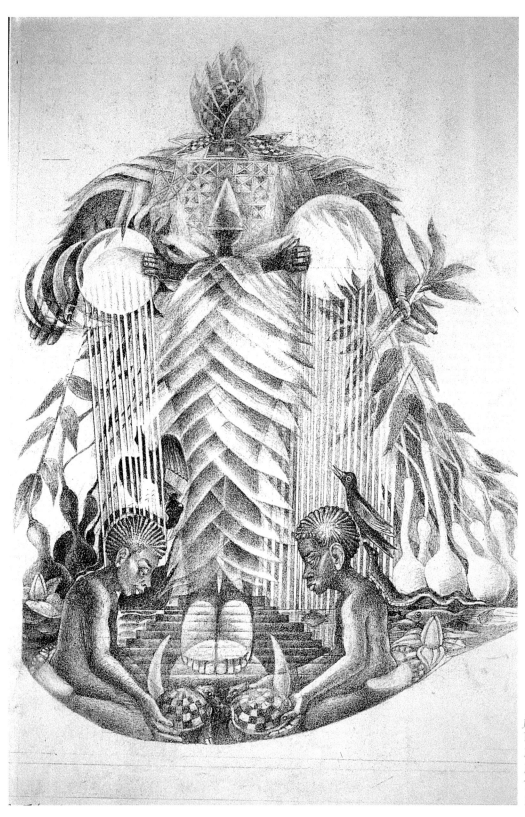

figure 91
Rebirth
Preparatory drawing for
Lithograph folio
The Grandmothers
1994

figure 92
Lift Us Up
Preparatory drawing for
Lithograph folio
The Grandmothers
1994

On the stool is a small egg echoing the elephant's shape. Overhead are a series of decorative combs. The two outside combs depict the familiar wash pot. The center comb is African in motif. Behind the combs rests a hare on the left, and a two-headed turtle on the right. The texture of the boat/bird suggests a basket. The water is teeming with small fish. It is an arresting image but what does the elephant mean? John Biggers answered with a twinkle in his eyes and a chuckle: "When I use the elephant, it is a symbol of fullness, representing woman. I want people to say, 'There's an elephant. What does it mean?' One can't dismiss an elephant as you can a butterfly."[23]

Morning Star - Evening STAR. 2.

figure 93
Morning Star, Evening Star
Preparatory drawing for
Lithograph folio
The Grandmothers
1994

RETURN TO SOURCE 5.

figure 94
Return to the Source
Preparatory drawing for
Lithograph folio
The Grandmothers
1994

Offering a few more clues, Biggers reviewed his own language of metaphor. "The grandmother was represented by three combs. The wash pot indicated cleansing, and depicted the soul. The family was on an ark, a bird's body. The ark floated in water, which the source of life. And life began as an egg in the womb." [24] The two-headed turtle represented the man, the artist John Biggers. *Return to the Source* (1994) pictured the endless cycle of birth, rebirth, and regeneration. The artist has come a long way indeed from the images that predominated in his early work.

The decade of the 1990s became one of far greater recognition for John Biggers. Not only did private collectors prize and select his work for purchase but museums also acquired more of his work. The Smithsonian Institution purchased his painting, *Shotgun #1* (1966) for their permanent collection. He was invited to exhibitions throughout the South. The Hampton University Museum purchased works representative of his whole career and he was also honored by Penn State University. According to Yale art historian Robert Ferris Thompson in the *Penn Stater* (November/December 1997), Biggers had done much to establish the legitimacy of African American art in the United States. Thompson asserted that Biggers stretched people's vision, and had shown a new way of seeing a culture within the dominant culture. "His genius lies in his ability to take the humble elements of everyday black life and transform them into something grand."[25]

The Museum of Fine Arts, Houston, with the Hampton University Museum, organized the first major retrospective exhibition of his work. *The Art of John Biggers: View from the Upper Room* included 127 pieces and traveled to four other venues in addition to the Museum of Fine Arts, Houston. They were the North Carolina Museum of Art in Raleigh, North Carolina, the Hampton University Museum; Wadsworth Atheneum, Hartford, Connecticut; and the Museum of Fine Arts, Boston. This exhibition generated a great deal of interest in Biggers's body of work and drew record-breaking large crowds. Of the works he had sold, Biggers said that he felt pangs of regret when letting them go, and remarked that

"This show [the retrospective] is like seeing a lot of best friends, and one ain't better than the other."[26] The Hampton University Museum published *The Murals of John Biggers, American Muralist, African American Artist,* in October 1996.

Several reviews from the exhibition were of particular interest. *The New York Times* commented: "Mr. Biggers's work has tremendous emotional gravity and dignity … His drawings from these early years, characterized by strong sinuous lines, are often outstanding: one of the best murals, the 1957 *'Web of Life'* is for the most part simply a large, elaborately cross-hatched drawing full of … hidden images."[27] Owen McNally, in *The Hartford Courant,* compared Biggers's work to that of the jazz musician John Coltrane. "Like Coltrane, who worked with layers of sounds … Biggers paints work thick with layers of symbols, sheets of visual metaphors rooted in African iconography. His works are like tangled banks thick with lush symbols, lore and ambiguity." [28]

The *Hartford Courant* review, comparing Biggers's approach to painting with John Coltrane's music, pleased Biggers greatly. It seemed to him that the reviewer really understood his work and his debt to jazz. Hazel Biggers saved the review for him and he reread it many times. They equally enjoyed the museum openings, traveling, and meeting new people and seeing old friends.

Despite his sense of fulfillment, John Biggers became exhausted, finding it very difficult to eat. His health fell into a serious decline. Diabetes and glaucoma had been with Biggers for a long time but the diabetes now required more intense treatment.[29] While he and Hazel were traveling, they carried portable dialysis equipment. Once home, Biggers went immediately into the dialysis center for treatment. He began to feel better and soon they began a remodeling project, making room for a dialysis machine in their bedroom.

So when the University of Houston approached him about doing a mural for their new Student Life Center, the ideas came and he could not refuse. Biggers asked his friend and colleague, painter Harvey Johnson, to assist him with the

actual painting on the wall as his nephew Jim Biggers had done some years earlier. In order to bring the University of Houston students into the process, he invited interested bystanders into the actual painting process. Developing a routine of alternating days between work and dialysis treatments, Biggers finished his original pencil drawings, and with his team, completed *Salt Marsh*. It was formally dedicated February 19, 1998.

An ecological theme ran through *Salt Marsh* (1998), so named because of the University of Houston's location along an environmentally endangered downtown bayou. His original pencil drawings (fig. 95) made reference on the far left to the Native Americans who were the earlier inhabitants of the area with the inclusion of profiles from the Buffalo nickel. That coin was a reference to Houston's Buffalo Bayou. However, as his color drawings enlarged and were developed, the African heritage images began to dominate (fig. 96). We recognize familiar images from *Family Ark* (1992) and *Grandmother* (1994) (fig. 97).

However, when the artist was asked about the story (fig. 98), he introduced a theme hardly mentioned, the race between the hare and the turtle. Biggers explained, "On one side, there was the great rabbit and the other, the great tortoise. The rabbit is the moon and the turtle is the sun. Their race across the sky is a great orbit in which they revealed the seasons of the year. Metamorphosis. Transformation. Ascension. That's what it's all about."[30] Upon reflection of these many layers of meaning, I've come to think that this great orbit across the sky might have symbolized the finish of the quilt that was John Biggers's life. The steady turtle was getting tired.

John Biggers and Harvey Johnson worked on one more project together, a rich and glowing mural, *Nubia, the Origins of Business and Commerce* (1999). Texas Southern University President Priscilla Slade requested a mural for the Jesse H. Jones School of Business. Due to Biggers's declining health, the preliminary drawings were primarily Johnson's and so are not included in this book.

The dominant themes of John Biggers's later life might well be characterized by his descriptive words: "Metamorphosis. Transformation. Ascension." His own art had undergone a painful, self-driven metamorphosis. His final transformation of form allowed Biggers to develop a metaphoric language so he could speak in universal truths. The idea of ascension reflected his underlying hope that his stories will speak with meaning to the generations that follow. He saw life as a constant striving upwards towards the light.

Despite the ravages of his illnesses, he continued to balance days in his studio and days in dialysis treatments until his body became exhausted. With sketches for new work still on his drawing board, the African American artist's rich quilt of life was completed on January 25, 2001. John Biggers left behind the treasury of his art that expressed his hope-filled beliefs in the possibilities of the human family for metamorphosis, transformation, and ascension to the heights of the human spirit. We are left to consider the messages of John Biggers's story.

figure 95
Salt Marsh
Pencil drawing
1997

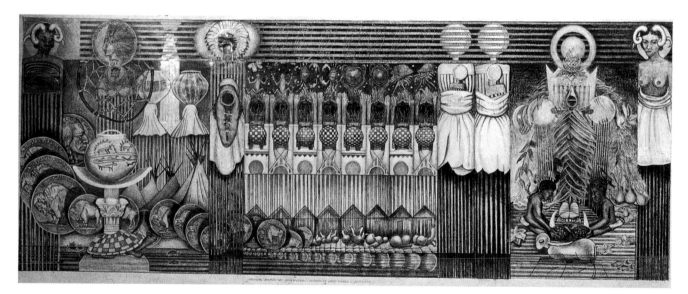

figure 96
Salt Marsh
Mural, University of
Houston
Color pencil
preliminary drawing
1998

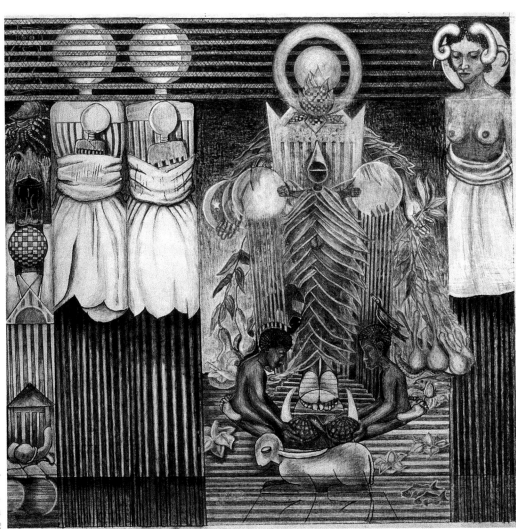

figure 97
Detail, drawing,
Salt Marsh
1998

figure 98
John Biggers
drawing,
Salt Marsh
1997

Afterword

This manuscript was completed during the time of the great hurricane Katrina-caused flood in New Orleans on August 31 and the first week of September 2005. While I watched television news covering the flooded city and its stranded citizens who were so disproportionately African American and poor, John Biggers's drawings came to my mind. In his early drawings he had depicted the struggle of the working poor with such empathy. It was the part of life that he had known the best. He had seen the exhaustion of a mother trying to shield her children from poverty and illness. He knew the desperation of the elderly without resources who could not care for themselves. The faces glimpsed on the flickering screen could have come from John Biggers's sketchbook. He was well acquainted with poverty, racism, and injustice.

He spent the last half of his career infusing his art with optimism and hope. He had a passion for art and believed that somehow his art could lift up his cherished people to the very best of life. As he came to accept and treasure his life's journey as an African American pioneer, he developed powerful iconic images that resonated with many viewers. Television viewers of Katrina's destruction agonized while watching so many families clinging together, desperate for help. Those tragic circumstances reaffirmed that all people comprise one human family. John Biggers knew that truth and held it sacred. His art was filled with a reverence for the family, past, present, and future. He offered his art as a gift to the future.

John Biggers has surely attained his goal, that of speaking to the human spirit through his uniquely African American art.

figure 99
John and Hazel
Biggers in their
garden
1998

figure 100
John Biggers
in front of his studio
1998

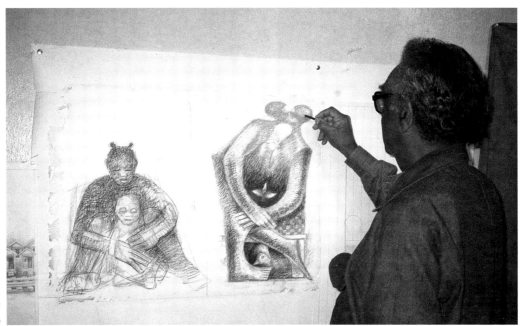

figure 101
John Biggers at work
in his studio

figure 102
Hazel Biggers and
author (photo by
John Biggers)

figure 103
John Biggers working
in his studio

Endnotes

Chapter One Endnotes

[1] John Thomas Biggers, Carroll Simms, and John Edward Weems, *Black Art in Houston: The Texas Southern University Experience* (College Station: Texas A&M University Press, 1978), 62.

[2] Alvia Wardlaw, *The Art of John Biggers: View from the Upper Room* (Houston, TX: H. N. Abrams, 1995), 75.

[3] John Biggers, conversation with author, February 20, 1998.

[4] John Biggers, conversation with author, November 22, 1998.

Chapter Two Endnotes

[1] Ferrie Biggers Arnold, conversation with author, October 16, 1995.

[2] *John Biggers's Journeys (A Romance)*, VHS (Chloe Productions, 1995).

[3] Biggers, Simms, Weems, *Black Art in Houston*, 4.

[4] Rededication Ceremony, *The History of Negro Education in Morris County*, VHS, October 27, 1989.

[5] *John Biggers's Journeys.*

[6] Ibid.

[7] Mildred Williams Cooper, "The History of Samuel Adam Webber," photocopy, Roberts Family History, 1977, 1–3.

[8] *John Biggers's Journeys.*

[9] Ibid.

[10] John Biggers, conversation with author, November 21, 1998.

[11] John Biggers, conversation with author, February 20, 1998.

[12] Ibid.

[13] Ibid.

[14] Ibid.

[15] *John Biggers's Journeys.*

[16] Mark St. John Erickson, "Drawn Back to Hampton," *Hampton Daily Press*, December 2, 1990.

[17] *John Biggers's Journeys.*

[18] Biggers, Simms, and Weems, *Black Art in Houston*, 7–8.

[19] John Biggers, conversation with author, August 21, 1995.

[20] Ibid.

[21] *John Biggers's Journeys.*

[22] John Biggers, conversation with author, August 21, 1995.

[23] Ibid.

[24] Wardlaw, *The Art of John Biggers*, 32–33.

[25] John Biggers, conversation with author, November 21, 1998.

[26] Wardlaw, *The Art of John Biggers*, 33.

[27] John Biggers, conversations with author, July 5–8, 1993.

[28] John Biggers, conversations with author, March 12–13, 2000.

[29] Ibid.

[30] John Biggers, telephone conversation with author, June 24, 1995.

[31] John Biggers, conversations with author, July 5–8, 1993.

[32] Robert Ferris Thompson, "John Biggers's *Shotguns* of 1987: An American Classic," in Wardlaw,
The Art of John Biggers, 108.

[33] Rebecca Felts and Marvin Moon, "Artist Series: An Interview with John Biggers," *Texas Trends in Art Education* 2 (1983): 14.

[34] Olive Jensen Theisen, *The Murals of John Thomas Biggers, American Muralist, African American Artist* (Hampton, VA: Hampton University Press, 1996), 19.

Chapter Three Endnotes

[1] Theisen, *Murals of John Biggers*, 19.

[2] Hazel Biggers, conversation with author, January 28, 2005.

[3] Biggers, Simms, and Weems, *Black Art in Houston*, 17–18.

[4] John Biggers, conversation with author, November 21, 1997.

[5] Biggers, Simms, and Weems, 60.

[6] John Biggers, conversation with author, August 20, 1995.

[7] Theisen, *Murals of John Biggers*, 20.

[8] John Biggers, conversation with author, November 20, 1998.

[9] Felts and Moon, "Artist Series," *Texas Trends in Art Education*, 16–17.

[10] John Biggers, conversation with author, November 20, 1998.

[11] Biggers, November 21, 1998.

[12] Conté crayon. Overall: 18 ¼ x 23 ¼ in. (46.35 x 59.06 cm.).
Reproduced with permission Dallas Museum of Art, Neiman-Marcus Company Prize for Drawing,
Fifth Southwestern Exhibition of Prints and Drawings, 1952.

[13] Theisen, *Murals of John Biggers*, 20.

[14] John Biggers, conversation with author, November 21, 1998.

[15] Ibid.

[16] Ibid.

[17] Biggers, Simms, and Weems, *Black Art in Houston*, 60–61.

[18] John Biggers, conversation with author, November 21, 1998.

[19] Reproduced by permission of Harry Ransom Humanities Research Center, The University of Texas at Austin.

[20] John Biggers, conversation with author, November 20, 1997.

[21] J. Mason Brewer, *Dog Ghosts and Other Negro Folk Tales* (Austin: University of Texas Press, 1958), 3–4.

[22] Jean Andrews, letter to the author, February 11, 1998

[23] Brewer, *Dog Ghosts*, 89–92.

[24] Ibid. 30–31.

[25] Ibid. 73–76.

[26] John Biggers, conversation with the author, November 21, 1997.

[27] Theisen, *Murals of John Biggers*, 32.

Chapter Four Endnotes

[1] Felts and Moon, "Artist Series," *Texas Trends in Art Education*, 10.

[2] John Biggers, conversation with author, February 20, 1998.

[3] John Biggers, *Ananse: The Web of Life in Africa* (Austin: University of Texas Press, 1962). 30.

[4] Biggers, *Ananse*, 3–29.

[5] Biggers, *Ananse*, 27.

[6] Wardlaw, *The Art of John Biggers*. 53.

[7] John Biggers, conversation with author, August 20, 1995.

[8] John Biggers, conversation with author, November 21, 1998.

[9] Biggers, *Ananse*, 28.

[10] Theisen, *Murals of John Biggers*. 37–39.

[11] Mimi Crossley, "Keeping Alive a Humanistic Tradition," Spotlight, *Houston Post*, July 25, 1976, 15, quoted in Biggers, Simms, and Weems, *Black Art in Houston*, 75.

[12] John Biggers, conversations with author, July 5–8, 1993.

[13] John Biggers, conversation with author, November 21, 1998.

[14] John Biggers, conversation with author, August 20, 1995.

[15] John Biggers, telephone conversation with author, December 6, 1996. In that conversation, Biggers described the presentation event: "I met President Johnson in Washington in the Cabinet Room. While he was holding my hand, he told us the story of how he'd integrated the colleges and universities in Texas. His hand was all bandaged. He said it was from handshaking too much, but his aides said he'd been in a fight the night before—too much corn liquor. When he came into a room, he was a *presence*. Dressed all in black, with shiny black shoes, he was an imposing figure."

Chapter Five Endnotes

[1] John Biggers, telephone conversation with author, June 24, 1995.

[2] Hazel Biggers, conversation with author, January 25, 2005.

[3] John Biggers, telephone conversation with author, July 29, 1993.

[4] Ibid.

[5] John Biggers, telephone conversation with author, July 29, 1993.

[6] Ibid.

[7] Wardlaw, *The Art of John Biggers*, 55.

[8] Felts and Moon, "Artist Series," 9.

[9] Hazel Biggers, conversation with author, January 27, 2005.

[10] Kirk Varnedoe, *A Fine Disregard: What Makes Modern Art Modern* (New York: Harry N. Abrams, 1990).

Chapter Six Endnotes

[1] Thad Martin, "John Biggers: Artist Who Influenced a Generation," Ebony (March 1984), 90.

[2] It should be noted that this high school for Negro students was dedicated in March 1955, a year after the historic *Brown v. Board of Education* school board case, which declared segregated schools to be unconstitutional.

[3] John Biggers, conversation with author, August 20, 1995.

[4] John Biggers, conversation with author, February 20, 1998.

[5] John Biggers, conversation with author, August 20, 1995.

[6] Robert Ferris Thompson, "John Biggers's *Shotguns* of 1987: An American Classic," in Wardlaw, *The Art of John Biggers*, 111.

[7] John Biggers, conversation with author, February 20, 1998.

[8] Elaine Robbins, "Portrait of a Neighborhood," *Texas Journey* 4 (2004): 18–24.

[9] John Biggers, conversation with author, February 21, 1998.

[10] Alvia Wardlaw, "Reclamations," *Black Art: Ancestral Legacy*, 192.

[11] John Biggers, conversation with author, Northeast Texas Community College, February 3, 1993.

[12] John Biggers, conversation with author, February 20, 1998.

[13] John Biggers, conversation with author, August 20, 1995.

[14] Tom Patterson, "The Art of John Biggers: Celebrating Traditional Black Cultures on Two Continents," in exhibit catalog, *John Biggers: Drawings and Paintings* (Fayetteville, NC: Fayetteville Museum of Art, 1993).

[15] Ibid.

[16] John Biggers, telephone conversation with author, December 6, 1996.

[17] John Biggers, conversation with author, August 20, 1995.

[18] John Biggers, telephone conversation with author, July 29, 1993.

[19] John Biggers, telephone conversation with author, February 4, 1994.

[20] Ibid.

[21] Ibid.

[22] Ibid.

[23] Ibid.

[24] Ibid.

[25] Chris Tucker, "A New Way of Seeing," *The Penn Stater,* November /December 1997, 33.

[26] John Biggers, conversation with author, August 20, 1995.

[27] Roberta Smith, "In Connecticut, the Old Meets the New," art review, *The New York Times,* July 12, 1996.

[28] Owen McNally, *The Hartford Courant*, May 19, 1996, G4.

[29] His older brothers died from diabetes.

[30] Olive Jensen Theisen, "Two New Murals by John Biggers: *Salt Marsh* and *Nubia, the Origin of Business and Commerce,*" *Art Education* 54, no. 4 (2000): 22.

Bibliography

BOOKS AND EXHIBITION CATALOGS

Biggers, John Thomas. *Ananse: The Web of Life in Africa*. Austin: University of Texas Press, 1996.

Biggers, John Thomas, Carroll Simms, and John Edward Weems, *Black Art in Houston: The Texas Southern University Experience*. College Station: Texas A&M University Press, 1978.

Brewer, J. Mason. *Aunt Dicy Tales*. Austin: University of Texas Press, 1956.

———. *Dog Ghosts*. Austin: University of Texas Press, 1958.

Ellison, Ralph. *Invisible Man*. New York: Random House, 1995.

Graham, Lorenz. *I, Momolu*. Claremont, CA: Graham Books, 1987.

Harry Ransom Humanities Research Center. *Aunt Dicy Tales: John Biggers's Drawings for the Folktale*. Exhibition catalog. Austin: University of Texas Press, 1999.

Lowenfeld, Viktor. *Creative and Mental Growth*. rev. ed. New York: Macmillan, 1952.

Patterson, Tom. "The Art of John Biggers: Celebrating Traditional Black Cultures on Two Continents." *John Biggers: Drawings and Paintings*. Exhibition catalog. Fayetteville, NC: Fayetteville Museum of Art, 1993.

Perry, Regenia. *Free Within Ourselves: African-American Artist in the Collection of the National Museum of American Art*. Washington, DC: National Museum of American Art, Smithsonian Institution, Pomegranate Artbooks, 1992.

Rhodes, Colin. *Primitivism and Modern Art*. London: Thames and Hudson, 1994.

Ritter, Rebecca, and Jeffrey Bruce. *Five Decades: John Biggers and the Hampton Art Tradition*. Exhibition catalog. Hampton, VA: Hampton University Press, 1990.

Rosenfeld, Michael. *John Biggers: My America.* New York: Michael Rosenfeld Gallery, 2004.

Rozelle, Robert, Alvia Wardlaw, and Maureen McKenna, eds. *Black Art, Ancestral Legacy: The African Impulse in African-American Art.* Exhibition catalog. Dallas: Dallas Museum of Art with Harry N. Abrams, 1989.

Rubin, William, ed. *Primitivism in 20th Century Art: Affinity of the Tribal and the Modern.* Exhibition catalog. New York: Museum of Modern Art, 1984.

Theisen, Olive Jensen. *John Biggers: A Cultural Legacy.* Exhibition catalog. Mt. Pleasant, TX: Northeast Texas Community College, 1992.

———. *The Murals of John Biggers: American Muralist, African American Artist.* Hampton, VA: Hampton University Museum, 1996.

Varnedoe, Kirk. *A Fine Disregard: What Makes Modern Art Modern.* New York: Museum of Modern Art, 1990.

Wardlaw, Alvia. *The Art of John Biggers: View from the Upper Room.* Houston, TX: Harry N. Abrams, 1995.

ARTICLES IN PERIODICALS

Erickson, Mark St. John. "Drawn to Hampton." *Hampton Daily Press,* December 2, 1990.

Felts, Rebecca, and Marvin Moon. "Artist Series: An Interview with John Biggers." *Texas Trends in Art Education* 2, no. 8 (Fall 1983).

Martin, Thad. "John Biggers: Artist Who Influenced a Generation." *Ebony,* March 1984.

McNally, Owen. Review of *Web of Life. Hartford Courant,* May 19, 1996, G4.

Smith, Roberta. "In Connecticut, the Old Meets the New." *New York Times,* July 12, 1996.

Theisen, Olive Jensen. "Two New Murals by John Biggers: *Salt Marsh* and *Nubia, the Origins of Business and Commerce.*" *Art Education* 54, no. 4 (2000).

Tucker, Chris. "A New Way of Seeing." *The Penn Stater,* November/December, 1997.

VIDEOTAPES

An Interview with Alton Dacus: The History of Negro Education in Morris County, Texas. Produced by Northeast Texas Community College Learning Resource Center, Mt. Pleasant, TX, 1985.

John Biggers's Journeys (A Romance). Produced by Chloe Productions, Newport News, VA, 1995.

Kindred Spirits: Contemporary African-American Artists. Produced by KERA-TV, Dallas, TX, 1992.

Stories of Illumination and Growth: John Biggers's Hampton Murals. Produced by Cinébar Productions, Newport News, VA, for Hampton University Museum, 1991.

INDEX

PAGE NUMBERS IN *ITALICS* REFER TO PAGES WITH ILLUSTRATIONS.